To Joe & Mary Catherine,
 The best travelling companions ever! When are we going back to "do the South"?

Fondly,
Liz & Mike
Summer 1997

MONUMENTS IN THE PAST

PHOTOGRAPHS 1870 - 1936

THE OFFICE OF PUBLIC WORKS
PHOTOGRAPHIC ARCHIVE
Compiled by John Scarry

Baile Átha Cliath
arna fhoilsiú ag Oifig an tSoláthair

Le ceannach díreach ón
Oifig Dhiolta Foilseachán Rialtais, Teach Sun Alliance
Sráid Theach Laighean, Baile Átha Cliath 2
nó trí aon díoltóir leabhar

To be purchased through any Bookseller, any Office of Public Works heritage site, or directly
from the Government Publications Sales Office, Sun Alliance House, Molesworth Street, Dublin 2

ISBN 07076 0169 X (Paperback)
ISBN 07076 0193 2 (Hardback)

Concept: John Scarry
Design and Production: Centraline Creative, Dublin, Ireland
Duotone Separations by: City Office Ltd.
Printed by: Brookfield Printing Co. Ltd.

PUBLISHED BY THE STATIONERY OFFICE
DUBLIN

CONTENTS

ACKNOWLEDGEMENTS

The following people have contributed
help and information towards the production of this publication:
The staff of the National Monuments and Historic Properties Service, Office of Public Works;
Tom Condit, Henry Wheeler; Ann Hamlin, *Historic Monuments and Buildings Branch,
Department of the Environment for Northern Ireland*;
Noel Kissane, *National Library of Ireland*;
Mairead Dunleavy, *National Museum of Ireland*;
Noel Nesbitt, *Ulster Museum, Belfast*;
Siobhan de hÓir, *Royal Society of Antiquaries of Ireland*.

Front Cover: The Cross of Muiredach, Monasterboice, Co. Louth, c.1870
Frontispiece: Inisfallen, Romanesque church, Co. Kerry, 1891
Back Cover: Young boy at Sligo Friary, 1873

FOREWORD TO THE PHOTOGRAPHS

All of the photographs reproduced in this book are from the Office of Public Works Photographic Archive. Most of them were printed from quarter plate glass and film negatives, some were contact-printed from whole plate glass negatives, and some of the earliest (*circa* 1870 – 90) were re-photographed from faded prints where no negative exists. Although many of the photographs were not dated, the earliest exact date we have for the quarter plates in the collection is 1895. The later photographs from the 1930s are from the more familiar 6 x 9 centimetre format roll film.

As this collection pre-dates the establishment of a photographic section in the Office, the prints and negatives were acquired from different sources. Some would have been taken by members of the inspecting staff of the time, while others were donated by members of the Royal Society of Antiquaries. The Office also commissioned a number of photographic firms, including T.P. Geoghegan of Sackville Street, Dublin, Ward and Company of Cork and R.J. Welch of Belfast. Robert John Welch (1859 – 1936) was contracted by the Office of Public Works to photograph monuments in County Kilkenny in July 1914 and on the 14th of that month he also visited Clonmacnoise, Co. Offaly (see pages 12 and 13). Two other photographs by him of Carrowmore and Knocknarea, Co. Sligo, which were acquired by the OPW at the time, are included in this book (pages 48 and 59). The original negatives of these, along with the rest of the Welch collection, are housed in the Ulster Museum, Belfast. The photograph of Roscrea Castle on page 61 is from a Laurence print. The Laurence collection of negatives is in the National Library of Ireland.

Part of the work of caring for any building or monument involves recording how it looks at any given time. In the seventeenth and eighteenth centuries many artists and engravers recorded ancient sites, often using some artistic licence to 'improve' the appearance of their subject. The arrival of photography in the mid nineteenth century provided a revolutionary way of recording subject detail accurately and almost instantly, something we now take for granted. Today, with modern techniques, photography plays an important part in recording historic sites for conservation, restoration and archaeology.

Every year many thousands of people visit the monuments of Ireland. Many of these photographs show them just as they looked in the late nineteenth and early twentieth century, often in a poor state of preservation. Nevertheless the photographs in this book are the earliest objective visual record of those monuments and the people that visited them.

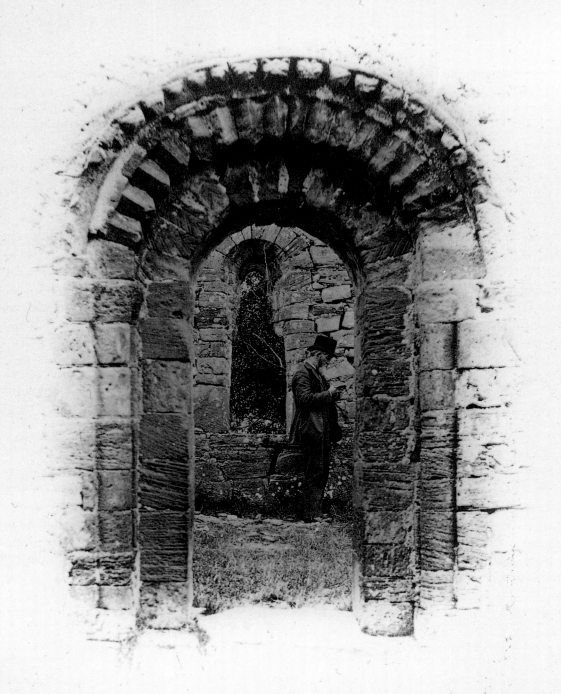

CARING FOR MONUMENTS
The State's role in the early years

Provision for the care of monuments in Ireland began in 1869 with the passing of the Irish Church Act. The Kilkenny Archaeological Society, a body which has evolved into the Royal Society of Antiquaries of Ireland, carried out work before this with very limited resources. For instance, £180 was spent at Jerpoint Abbey in 1857, and the east window of the Franciscan Friary, Kilkenny, was opened up under the direction of Thomas Drew, who gave his services free. Much other good work was done by this Society which, in this respect, was the forerunner of the National Monuments Branch of the Office of Public Works.

The primary objective of the Irish Church Act of 1869 was to dis-establish the Church of Ireland. Churches still in use, with their graveyards, were vested in the Representative Body of the Church of Ireland. Most other graveyards were handed over to Burial Boards, whose powers were subsequently taken over by local authorities. Some of the disused structures in graveyards were considered too interesting to be left unprotected, so the category of 'National Monument' was devised to provide for them.

The Commissioners of Public Works were given the job of looking after these monuments for which a lump sum of £50,000 was set aside out of funds in the hands of the Church Temporalities Commissioners.

The transfer to the Commissioners of these ecclesiastical buildings was subject to a ban on their use as places of worship. This ban on the use of National Monuments for religious purposes has remained to this day, subject to some exceptions where there has been a tradition of such ceremonies, like the annual pattern day at Clonmacnois.

The Irish Church Act became effective as regards its ecclesiastical provisions at the beginning of 1871, but the beginning of the Commissioners' concern with National Monuments dates from 27 October 1874, when the 'ruins of the Ancient Cathedral Church on the Rock of Cashel with the land adjacent thereto' were vested by the Church Temporalities Commissioners in 'the Secretary of the Commissioners of Public Works in Ireland'.

By the end of 1874 thirteen more monuments had been vested, including Monasterboice, the Ahenny Crosses and Glendalough. The first Inspector of National Monuments, or Superintendent as he was then called, was Mr (later Sir) Thomas Newenham Deane, one of a well-known family of architects, who took charge in March 1875. Works at Cashel, Ardmore, Glendalough and Ardfert then started without further delay. Most of the Irish Church Act vestings were architectural monuments, but there were also a number of dry-stone buildings, such as the Aran forts and the beehive huts and stone cashel at Inishmurray. The Ancient Monuments Protection Act for Britain and Ireland was passed in 1882, adding a further batch of monuments to the care of the Commissioners. This specified, in a schedule, a number of monuments which were not ecclesiastical, the owners of which could, if they so wished, appoint the Commissioners as owners or guardians. The distinction between ownership and guardianship continues to this day; about one third of the monuments in the care of the Commissioners are not owned by the State but have been placed by their owners in the guardianship of the Commissioners.

The scheduling of a monument under this Act allowed the Commissioners to proceed against anybody except the owner in the event of its being damaged or destroyed, completely ignoring the fact that the owner was the person most likely to do damage in the course

of developing his property. A classic instance occurred in the early 1900s when the owner of the Hill of Tara was persuaded to allow a band of British Israelites to dig up a large part of the Rath of the Synods in the belief that they would find the Ark of the Covenant buried there, and there was nothing the Commissioners could do to stop them.

In 1892 the Ancient Monuments Protection (Ireland) Act extended the provisions of the 1882 Act so that additional ecclesiastical monuments could be vested or taken into guardianship, since it was realized that not every worthwhile monument of this kind had been vested by the Irish Church Act. Another development was that, under the Land Acts of 1903 and 1923, if any land vested in a purchaser under the Land Purchase Acts contained any monuments which, in the opinion of the Land Commission, were important, the Land Commission could make an order vesting such monuments in the Commissioners of Public Works. Castles were, generally speaking, rather under-represented, as compared with prehistoric or ecclesiastical monuments, until the 1930s, when Harold Leask conducted a campaign to rectify this imbalance.

After the death of Sir Thomas Deane in 1899 his post was filled by Dr Robert Cochrane, described in the Annual Report as 'one of our Principal Surveyors', a term which was then used to describe the Commissioners' Architects. In 1911–12 the Royal Society of Antiquaries of Ireland, of which Dr Cochrane was at that time President, made strong representations to the Chief Secretary, Augustine Birrell, about the inadequacy of the existing legislation on the conservation of monuments and, in particular, the disappointing results of the provisions of the 1903 Land Act with regard to monuments. It was hoped that a Royal Commission similar to those being appointed for England, Wales and Scotland to prepare inventories of monuments worthy of preservation would also be appointed for Ireland. These representations achieved nothing, the excuse being that 'having regard to the contemplated changes in the Government of Ireland' the question of a Royal Commission for Ireland should be left for the consideration of an Irish government at some future time.

In 1916 Dr Cochrane died in his 71st year. He had done admirable work in the recording of monuments: his county guides to Cork, Wexford and Westmeath, which each appeared as appendices to the Annual Report, may be taken as examples, as may his series of articles on the ecclesiastical antiquities of Howth which he published in the *Journal of the Royal Society of Antiquaries of Ireland*. Cochrane's successor, Andrew Robinson, held office in the troubled period from 1916 to 1923, during which the Annual Reports were, not unnaturally, brief and meagre. After the passing of the Government of Ireland Act 1920, twenty-two monuments were transferred from the care of the Commissioners to the Works division of the Ministry of Finance in Northern Ireland, overseen by Dr D.A. Chart. (In 1976 the responsibility for Monuments work was moved from the Department of Finance when the Historic Monuments and Buildings Branch of the Department of the Environment (N.I.) was created.) In 1926 the Ancient Monuments (N.I.) Act was passed. This Act provided for the reporting of all archaeological finds, a provision adopted by Dáil

Robert Cochrane

Éireann in the 1930 National Monuments Act. In October 1923 the Commissioners appointed Dr Harold Leask as the Inspector of Monuments. He was, like his predecessors, only a part-time Inspector and spent much of his time designing new buildings, such as national schools. With the passing of the National Monuments Act of 1930 he became the full-time Inspector of National Monuments.

Between 1882 and 1930 there were two categories of monuments — National Monuments under the 1869 Act and Ancient Monuments under the 1882 Act. The funds for Ancient Monuments were voted by Parliament, while National Monuments continued to be maintained out of the lump sum provided by the Church Temporalities Commissioners. The National Monuments Act of 1930 abolished the rather meaningless distinction between Ancient Monuments and National Monuments. All were henceforth to be called National Monuments and to be maintained out of the annual vote.

Harold Leask

A monument was defined as 'any artificial or partly artificial building, structure, or erection whether above or below the surface of the ground and any cave, stone, or other natural product whether forming part of, or attached to, or not attached to the ground, which has been artificially carved, sculptured or worked upon or which (where it does not form part of the ground) appears to have been purposely put or arranged in position and any prehistoric or ancient tomb, grave or burial deposit, but does not include any building which is for the time being habitually used for ecclesiastical purposes'. This was a long and cumbersome definition, but it survived the test of time fairly well. (The 1987 Amendment Act, however, extended the definition to include a group of buildings, etc., a ritual, industrial or habitation site, and any place containing the remains or traces of buildings etc.)

Having defined a 'monument' the 1930 Act went on to define a 'National Monument' as 'a monument or the remains of a monument, the preservation of which is a matter of national importance by reason of the historical, architectural, traditional, artistic or archaeological interest attaching thereto'. An important new provision in the 1930 Act provided for the Minister for Finance to make a Preservation Order where in his opinion a National Monument was in danger of being or actually was being destroyed, injured or removed or was falling into decay through neglect. The 1954 Act delegated this power to the Commissioners.

A Preservation Order did not permit the Commissioners to do works to the monument in question, but if they felt that works were necessary they could become Guardians of the monument. This allowed them to spend public money on conservation works without interfering with the ownership of the property. The prohibition on unlicensed archaeological excavations was another important advance achieved by the 1930 Act. In Northern Ireland the Ancient Monuments Act of 1937 adopted from the 1930 Act the provision for licensing archaeological excavations, something that is still absent from legislation in Britain.

Further amendments were made to the National Monuments Acts in 1954, and a new Northern Ireland act was passed in 1971.

Current legislation in the Republic of Ireland also places legal restrictions on the use of metal detectors and on diving and retrieving objects from wrecks over 100 years old.

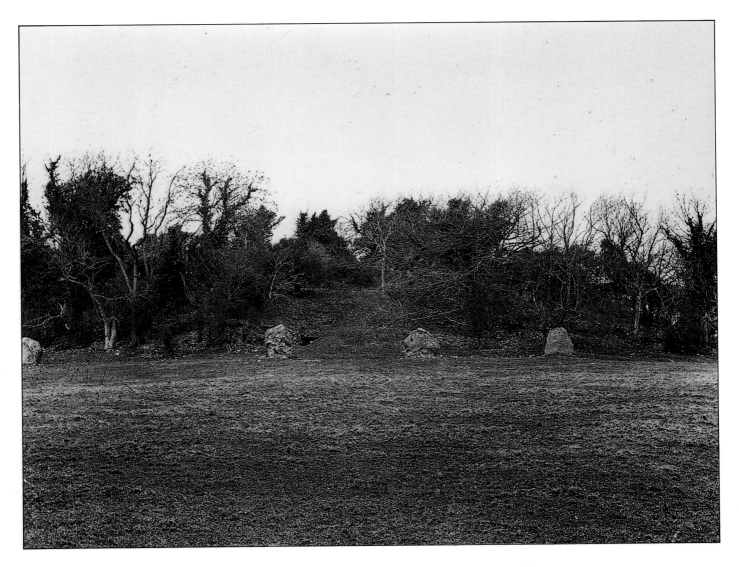

Newgrange Passage Tomb, Co. Meath, in 1908. Ireland's best-known prehistoric monument before modern research revealed its archaeological and astronomical significance.

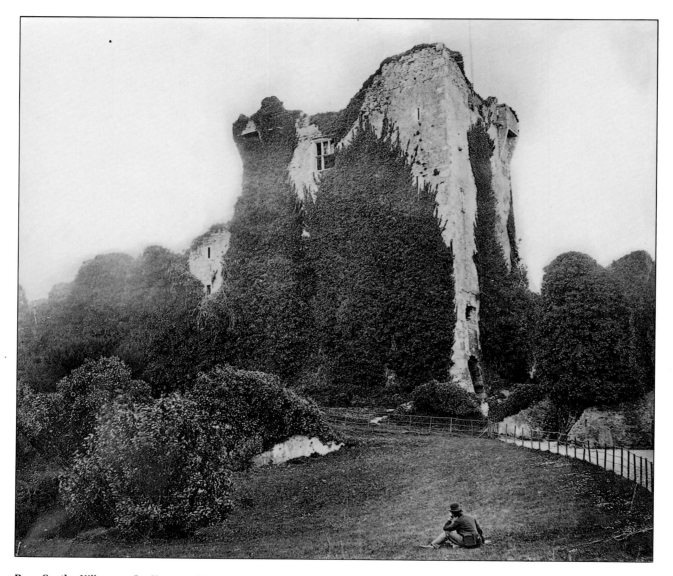

Ross Castle, Killarney, Co. Kerry, *c.*1870.
Built by one of the O'Donoghue Ross chief-
tains, this 15th-century tower was held by
Lord Muskerry and the Royalists in the
Cromwellian wars. A barrack block was
built against the south wall in the 18th
century.

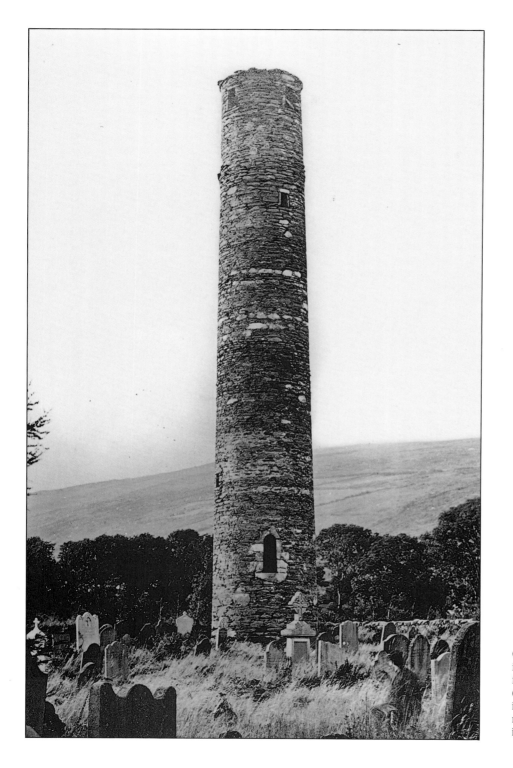

Glendalough Round Tower, Co. Wicklow, in 1875. A monastic settlement was founded in Glendalough by St Kevin, a 6th-century saint. One of the most strik-ing remains is the round tower, over 30 metres high. The conical cap was rebuilt in 1876, using the original stones.

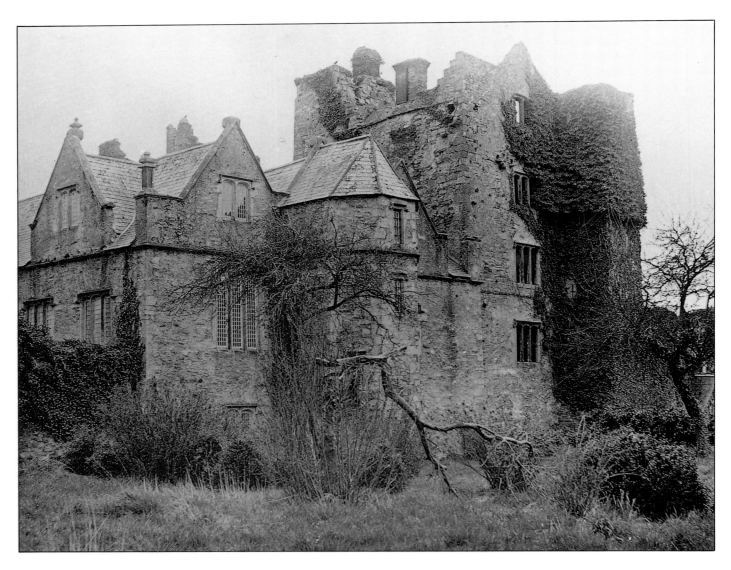

Carrick-on-Suir Castle, Co. Tipperary, *c.*1890. Thomas, Earl of Ormond, built a Tudor mansion, one of a handful in Ireland, in 1568 onto an earlier 15th-century castle which contained 4 towers and a curtain wall around a square enclosure. The Tudor mansion contains elaborate plaster friezes depicting Thomas Butler with Elizabeth I and Edward VI.

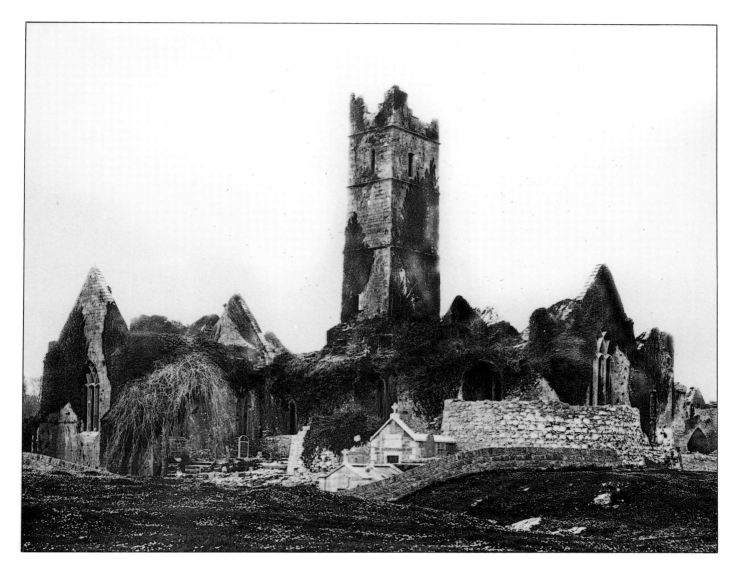

Quin Friary, Co. Clare. Overhanging branches give an eerie appearance to the extensive remains of this Franciscan friary, allegedly the first Observantine house in Ireland. The remains also cleverly incorporate part of the fabric of a Norman castle.

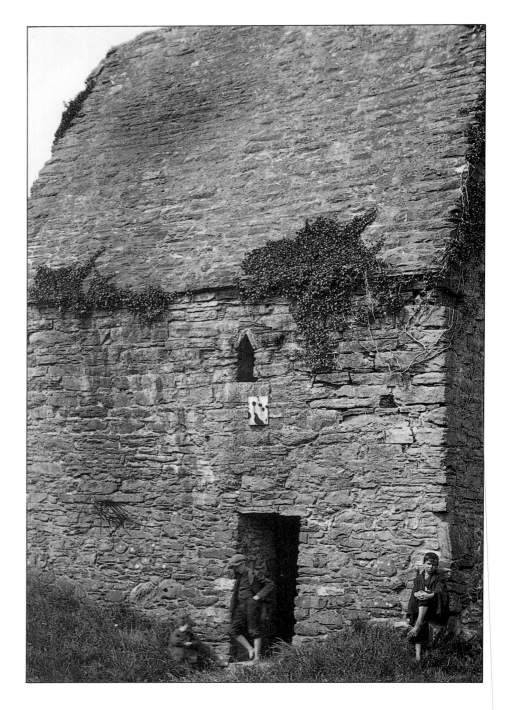

'St Columb's House', Kells, Co. Meath, in 1910. This oratory with its steep stone roof is associated with the famous monastery of Kells founded by St Colmcille in the 6th century. The entrance is modern; the original structure was entered by a door in the west wall.

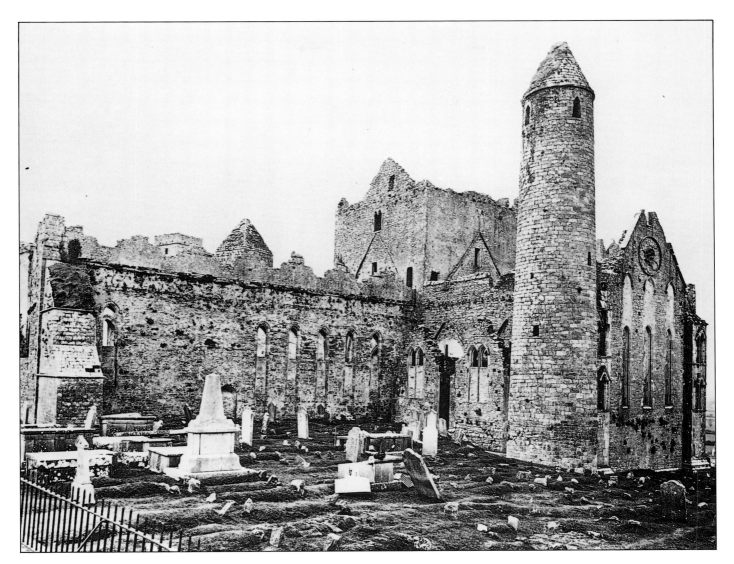

St Patrick's Rock, Cashel, Co. Tipperary.
The round tower dates from about 1100.
The cathedral is an aisleless building of
cruciform plan, with a later tower added.
The row of lancet windows seen here are
typical of Irish 13th-century building.

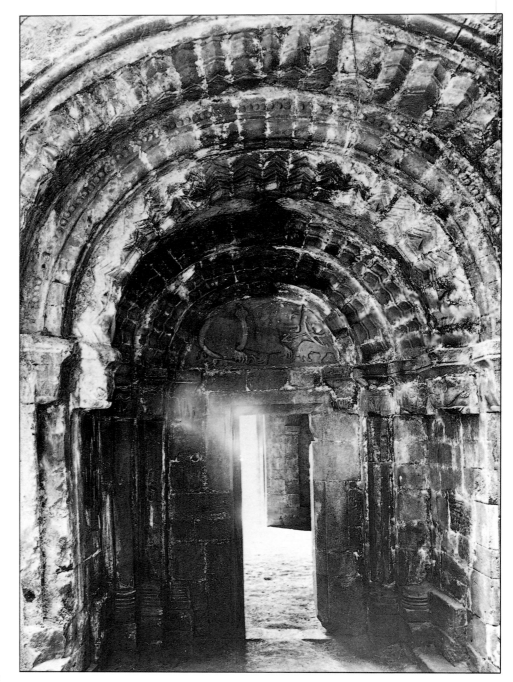

Cashel. The north doorway into Cormac's Chapel has a tympanum, rare in Ireland, depicting a centaur wearing a Norman helmet, shooting with a bow and arrow. This doorway was the main entrance to the chapel until the 13th-century cathedral was built against the chapel.

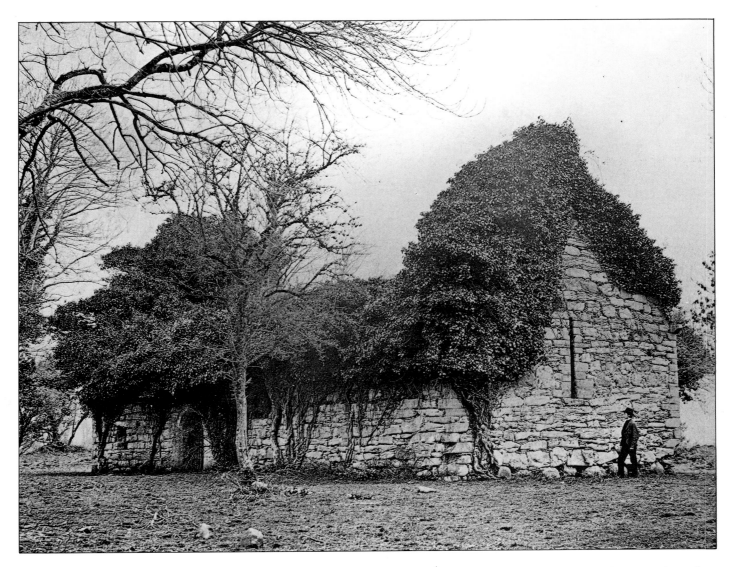

Lough Gill, Church Island, Co. Sligo. The remnants of a medieval church mark the site of a 6th-century foundation of St Loman's. A fire which destroyed the church in 1416 burned the total O'Cuirnin library.

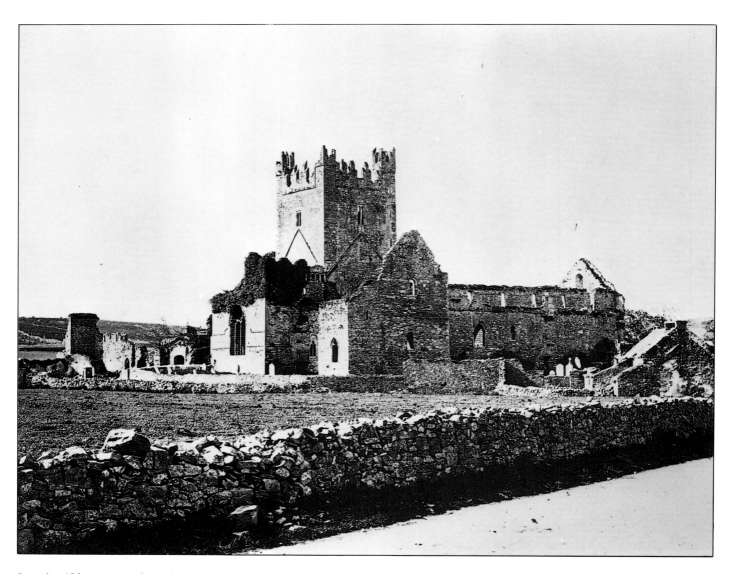

Jerpoint Abbey. A view from the north of
one of the finest Cistercian monasteries.
It was founded in 1150 and became a
daughter house of Baltinglass Abbey in
1180. The abbey was partly reconstructed
and the tower added in the 15th century.

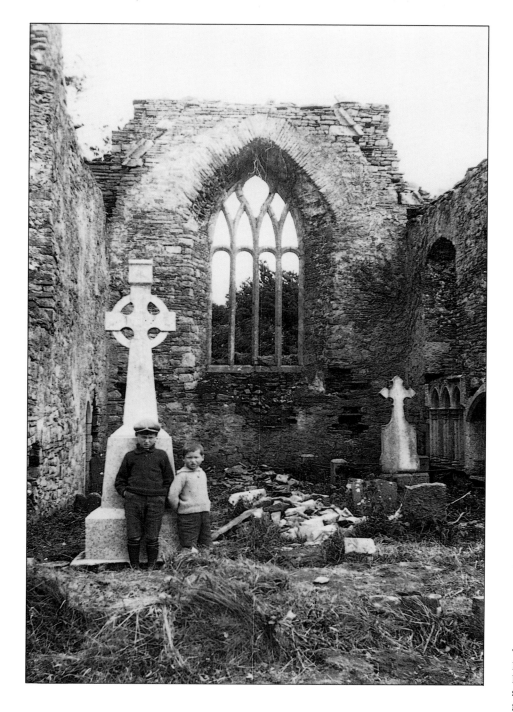

Two little boys at **Lislaughtin Friary,** Co. Kerry. Founded in 1478 by John O'Connor Kerry for the Franciscans, the fine triple sedilia of the choir is visible in the photograph.

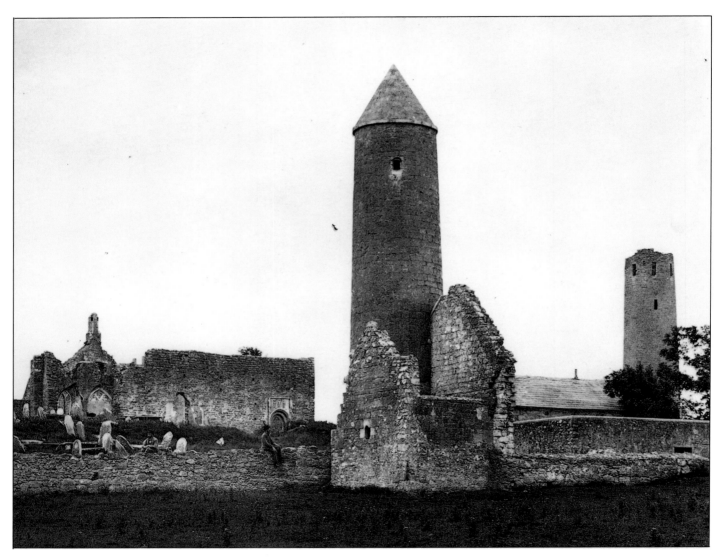

Clonmacnoise, Co. Offaly, 14 July 1914. One of Ireland's foremost early monasteries which was founded by St Ciaran in the 6th century. The remains are still extensive and form a picturesque group on the banks of the River Shannon. This photograph shows, from left to right, the cathedral, Temple Finghin with attached tower, the roof of the Church of Ireland church, and O'Rourke's Tower.

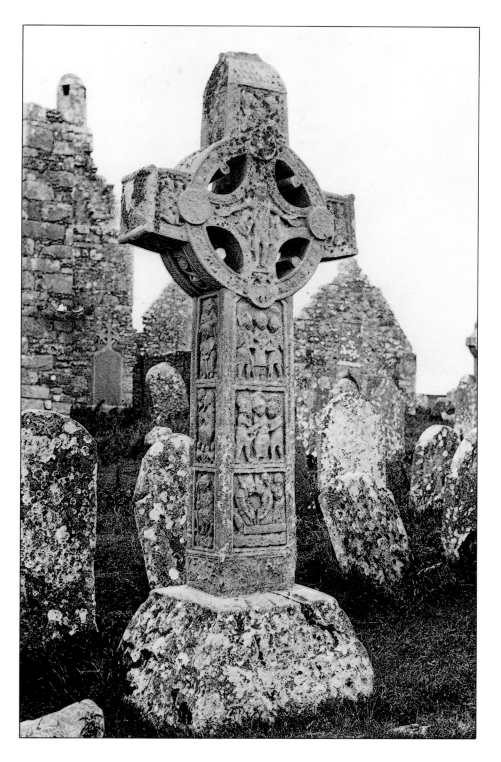

The Cross of the Scriptures, Clonmacnoise. This photograph, taken on 14 July 1914, shows one of the finest high crosses in Ireland. Much later, conservation works were carried out to the graveyard.

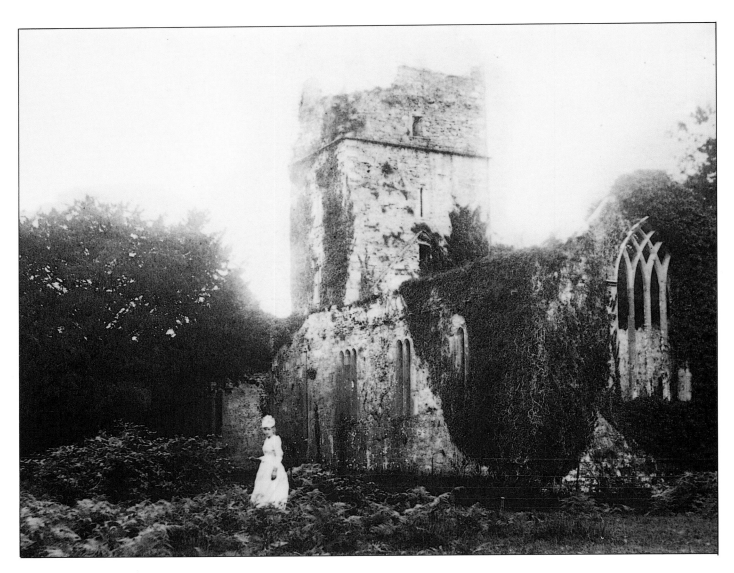

A mysterious lady at **Muckross Friary,** Co. Kerry. The best-preserved of the Franciscan friaries, it was founded in 1448 and completed about 1475. It contains a preserved cloister with an old yew tree in the centre. The friars were finally driven out when the monastery was burnt by the Cromwellians in 1652.

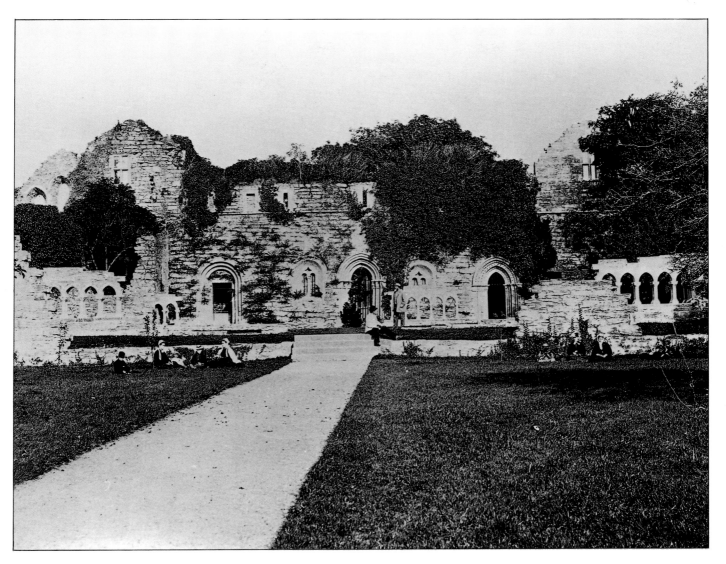

Cong Abbey, Co. Mayo. This photograph shows a group of people in front of the cloister range of the Augustinian Abbey said to have been built by Turlough O'Connor, king of Connacht in the 12th century.

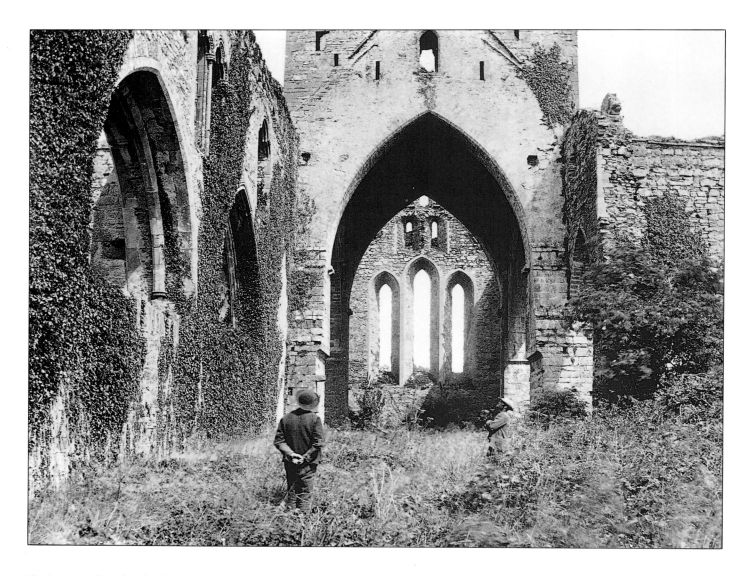

The interior of **Dunbrody Abbey,** Co. Wex-
ford, 19 July 1895. The tower of this Cis-
tercian abbey was added in the 15th
century.

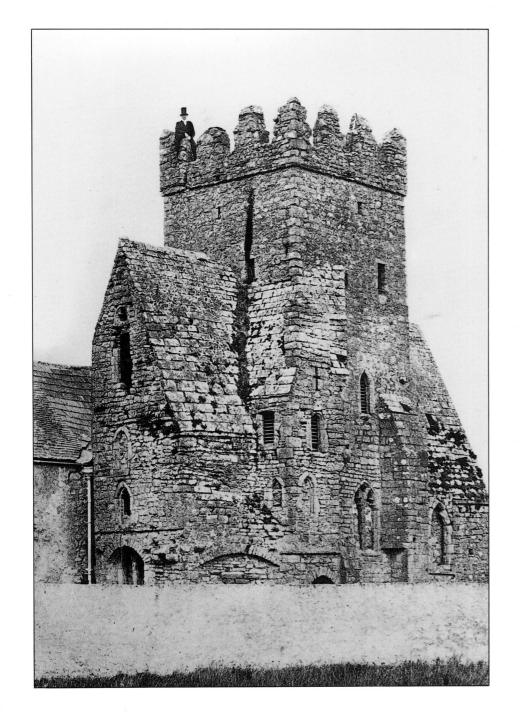

St Doulagh's Church, Co. Dublin. Showing the square tower of this unusual medieval church which is dedicated to St Doulagh, a 7th-century hermit.

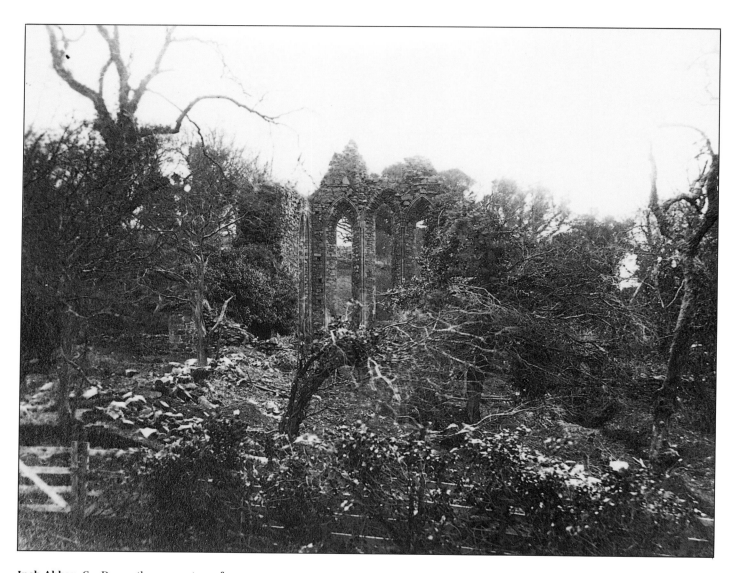

Inch Abbey, Co. Down, three-quarters of
a mile north-west of Downpatrick. This
photograph, which is credited to J. Phillips
of Belfast, shows the 12th-century Cister-
cian abbey before conservation work was
carried out.

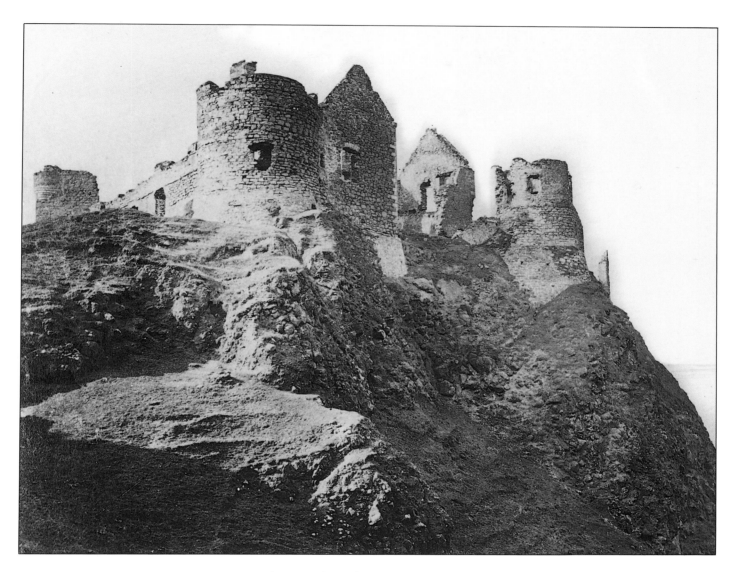

An unusual view from the east of
Dunluce Castle, Co. Antrim, *c.*1870.
Situated beside the coast road between
Portrush and Bushmills, the earliest parts
of the castle are probably 14th-century
but it is not documented until the 16th,
when it was in the hands of the MacQuil-
lans and later the MacDonnells.

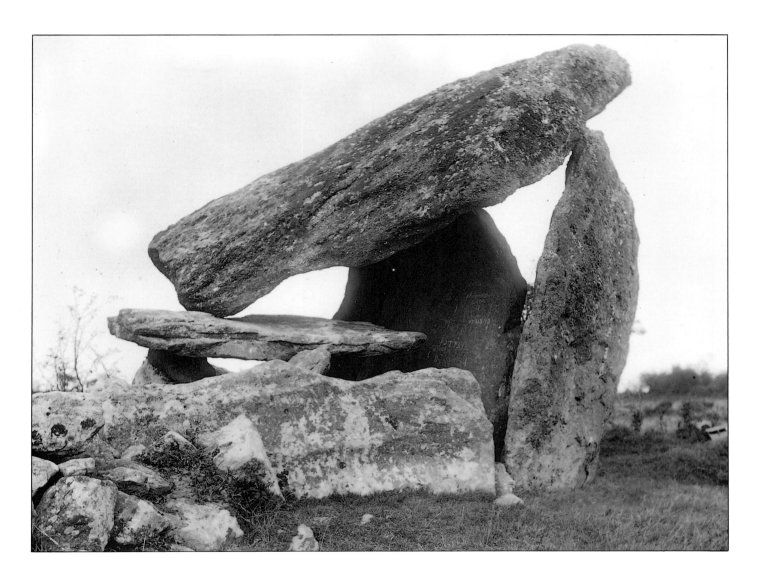

Kilmogue, Co. Kilkenny. 'Leac an Scail'
Portal Dolmen. A very large portal dolmen
with a steeply sloping capstone. Note the
graffiti on the sidestone.

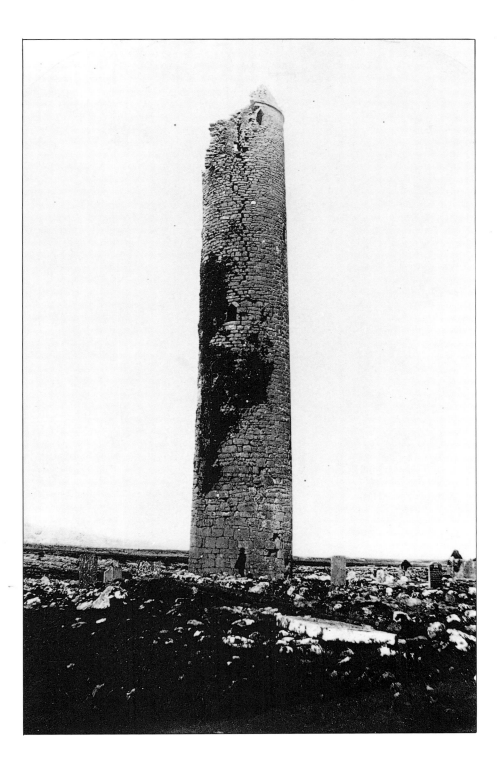

Kilmacduagh, Co. Galway, round tower. The monastery of Kilmacduagh was founded early in the 7th century by St Colman, son of Duogh, a member of one of the local royal families. It has one of the finest collections of churches in Ireland. This photograph was taken before repairs were carried out under the supervision of Sir Thomas Deane. From his report to the office, made in the year 1879, the following extract is taken:

'The condition of this structure was such as to render it a matter of much consideration whether repair was possible.

Its leaning position, and the dangerous rent running nearly from top to bottom, made it no easy matter to secure its safety. A large portion of the overhanging and crumbling masonry was carefully removed, and re-instated with the original stones; the dilapidated capping has been restored, and it is now perfectly safe.'

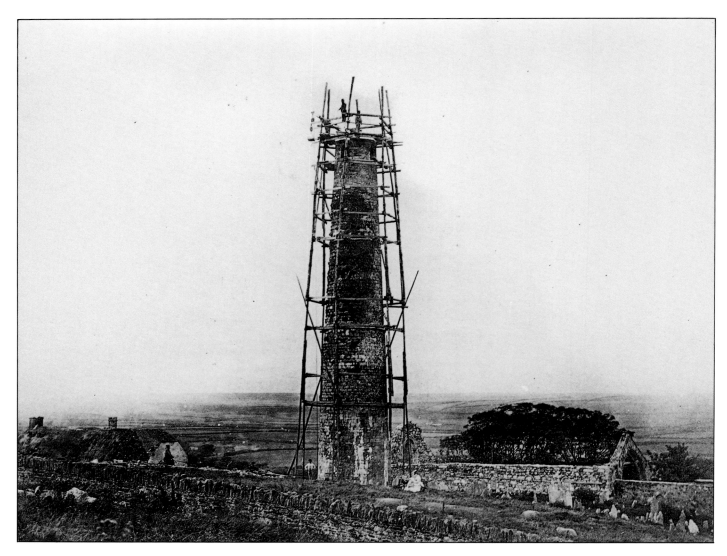

Ardmore, Co. Waterford, showing the
restoration of the round tower in 1875–6.
The original monastery was founded here
by St Declan, a 5th-century bishop. The
round tower was probably built in the
12th century, and is one of the finest in
Ireland.

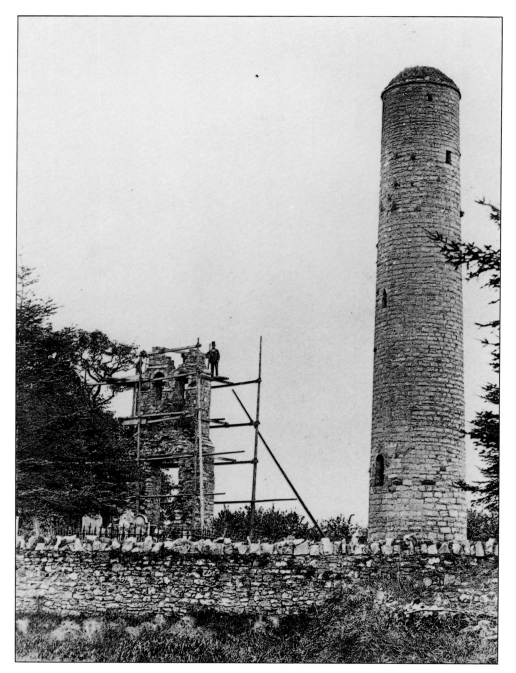

Donaghmore, Co. Meath, church and round tower. The early efforts of the Office of Public Works at looking after monuments in State Care resulted in the rescue of many of these ancient structures from ongoing ruin and collapse. St Patrick is said to have founded the first monastery here at Donaghmore.

The round tower lacks its characteristic top windows; these may have been omitted when the conical cap was replaced early in the 19th century. The repairs are being carried out to the later medieval church on the site.

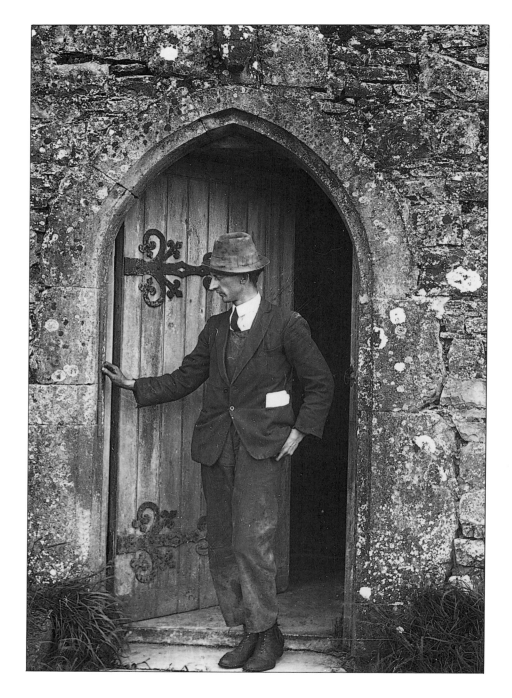

Taghmon, Co. Westmeath, church, 1925.
Carefully examining the doorway
of this 15th-century fortified church
dedicated to St Patrick. Note the medieval
head over the keystone.

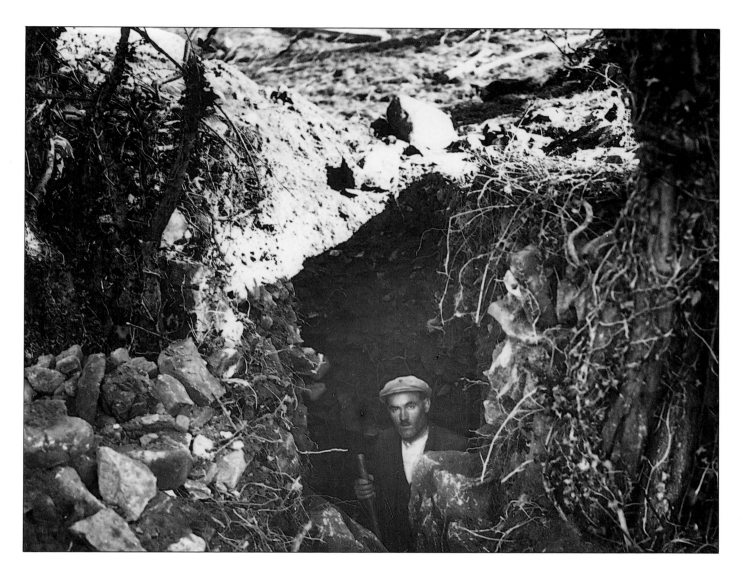

Dowth Passage Tomb, Co. Meath, in 1932. There are two chambers, one cruciform, with many decorated stones, in the great mound. The site suffered severely from the attentions of treasure seekers and road-makers and unlike its neighbours in the Boyne Valley it has not yet been archaeologically excavated or restored.

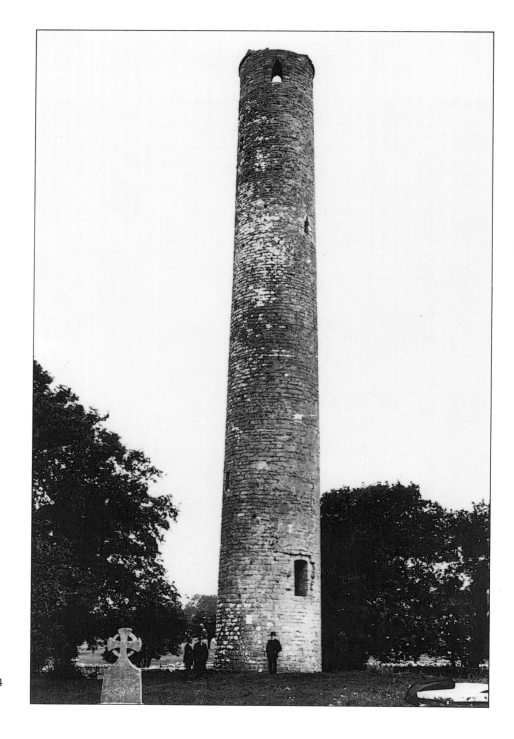

Grangefertagh Round Tower, Co.
Kilkenny. This is one of the photographs
taken for the Board of Works in July 1914
by Robert Welch. The 30-metre-high
tower had been damaged by fire in 1156.

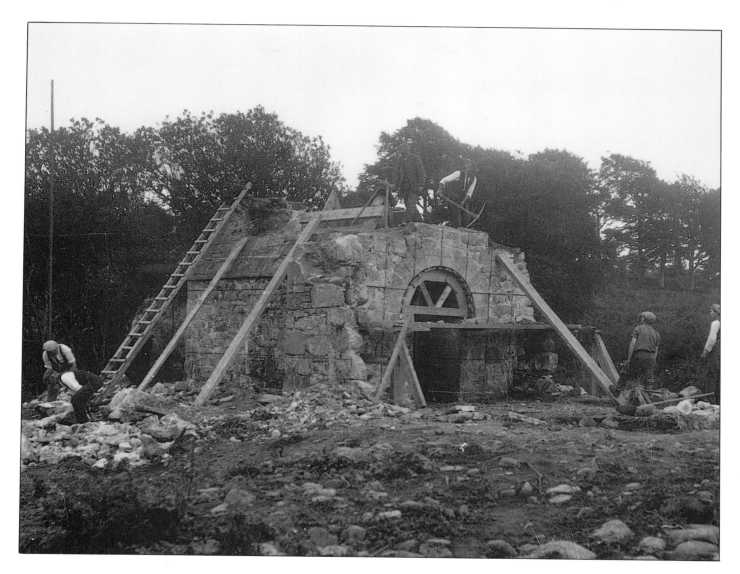

St Molua's Church, Co. Clare. The small, partially stone-roofed oratory of St Molua on Friar's Island in the Shannon was threatened in 1929 with total submersion as a result of the Shannon Hydro-electric scheme. A site was found for this in Killaloe, high above the river, and it was carefully re-erected there with every stone numbered.

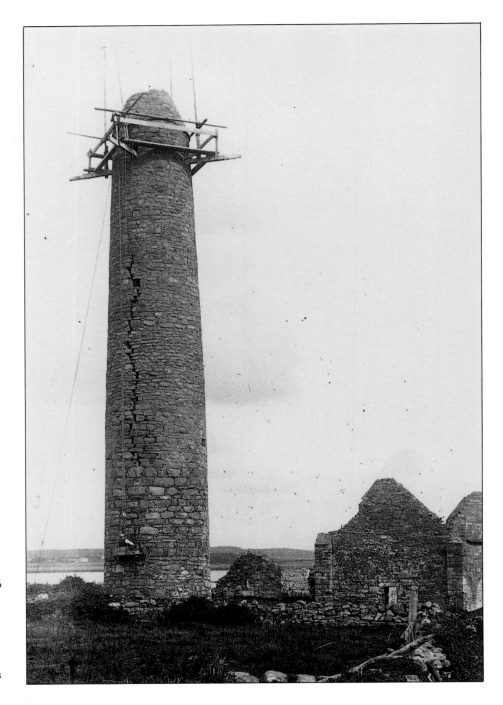

Precarious repairs being carried out on **the Round Tower at Scattery Island** on 16 March 1916. The monastery which overlooks the town of Kilrush was founded in the 6th century. It suffered greatly from Viking raids and may even have been occupied by them until its recapture by Brian Boru. The most conspicuous part of the monastery is the round tower, which is unusual in that the door is at ground level. To the east of the tower is the cathedral, a church with antae or projecting side walls and a lintelled doorway.

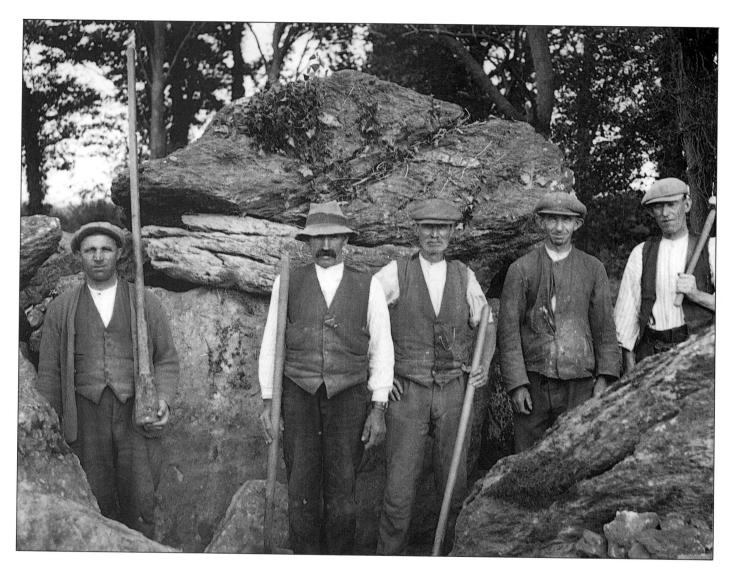

Workmen on the excavation of **Labba-callee Wedge Tomb,** Co. Cork, in 1934. This was the first excavation conducted under a new government scheme for the relief of unemployment and was directed by H.G. Leask and Liam Price. The rate of pay for the men was one guinea (£1.05) per week.

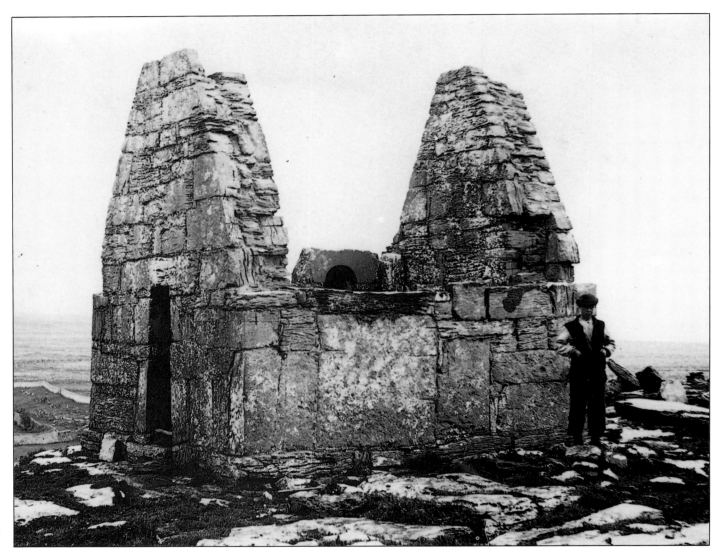

Inishmore, Co. Galway, about 1897. An Aran Islander stands beside the well-preserved stone oratory of Temple Benan. It has a distinctive Early Christian flat-headed doorway, and the side walls are built with exceptionally large stones. The site is associated with St Benan, a disciple of St Patrick.

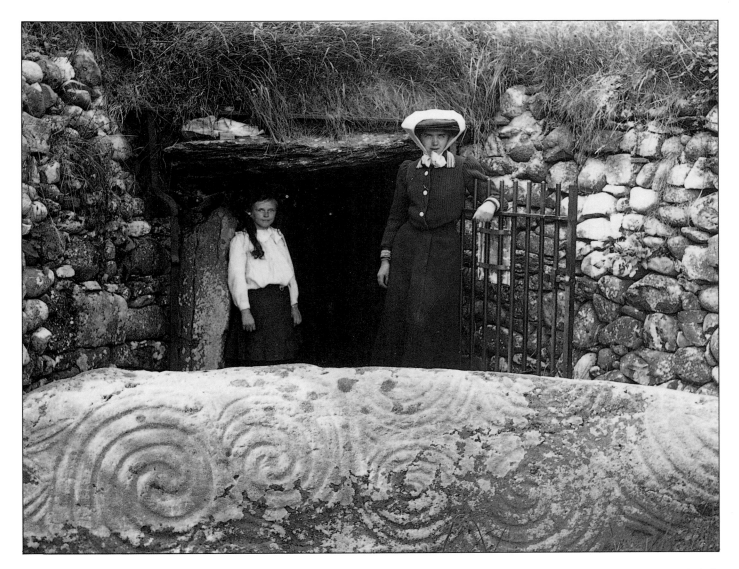

Newgrange, Co. Meath, about 1910. Suitably attired for the day's outing, the lady and child stand behind the famous decorated stone marking the entrance to the tomb.

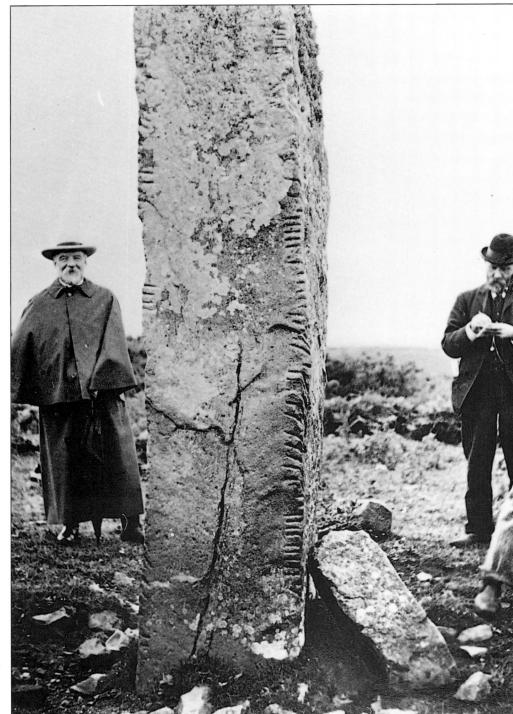

Breastagh Ogham Stone, Co. Mayo. J.D. La Touche and Robert Cochrane visiting this impressive pillarstone in 1898. The damaged inscription probably commemorates the grandson of a 5th-century local king, Amalngaid. The stone was re-erected in 1853.

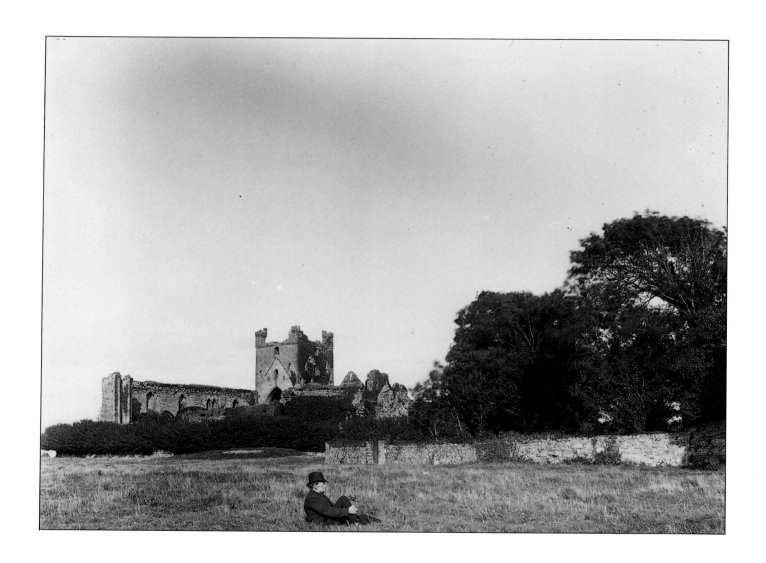

Dunbrody Abbey, Co. Wexford. Dunbrody is one of the longest Cistercian abbeys in Ireland and some of its domestic buildings remain. It was founded in 1175 by Hervey de Montemarisco, an uncle of Strongbow.

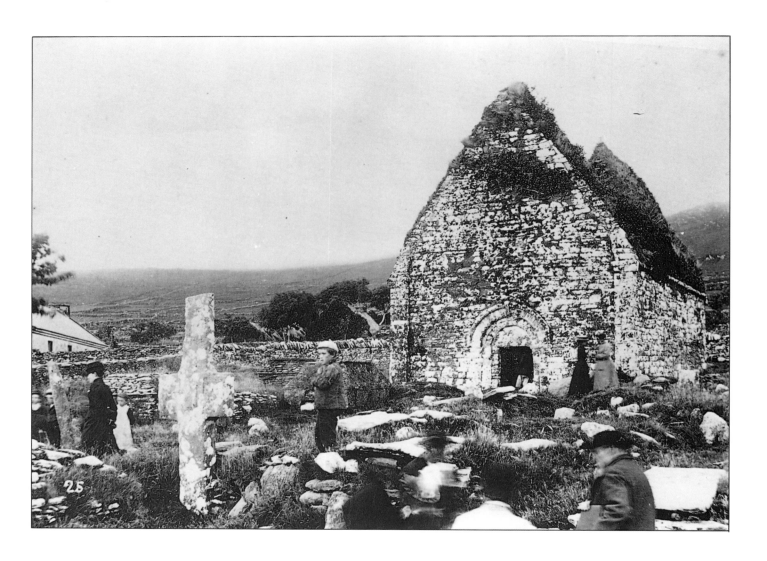

This photograph shows a number of
people arriving for a funeral service
at **Kilmalkedar Church,** Co. Kerry.

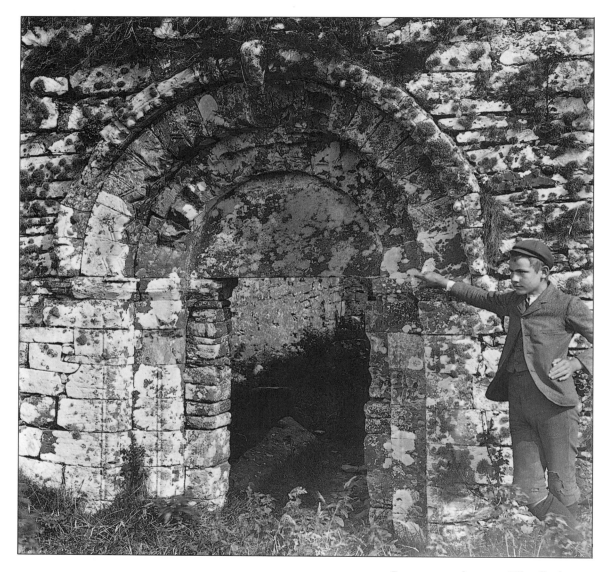

Romanesque doorway, **Kilmalkedar Church.** The tympanum of this 12th-century doorway has a head on one side and an imaginary beast on the other.

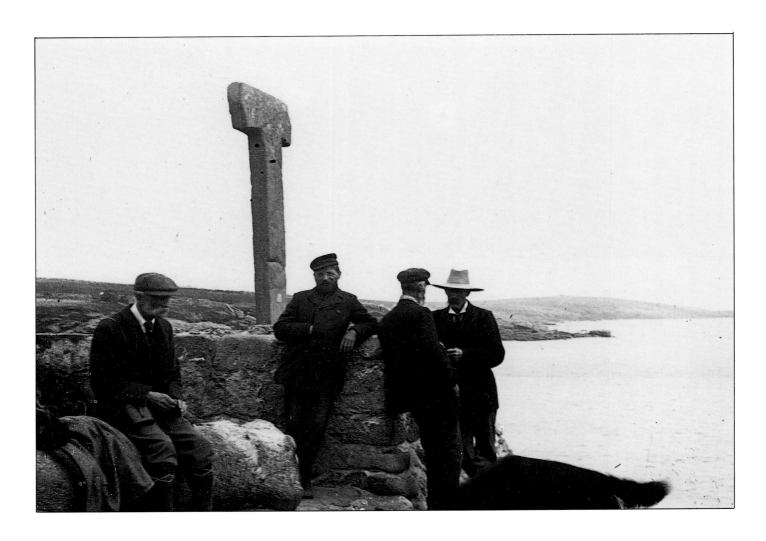

Cross, Tory Island, Co. Donegal, 1907.
Another excursion, this time to remote
Tory Island. The group relax in front of an
unusual undecorated T-shaped cross
which is associated with a round tower
and other scanty monastic remains. There
are also 'Cursing stones', said to have
been effectively used in 1884 when a gun-
boat was sunk during its effort to land
troops to collect rates from the islanders.

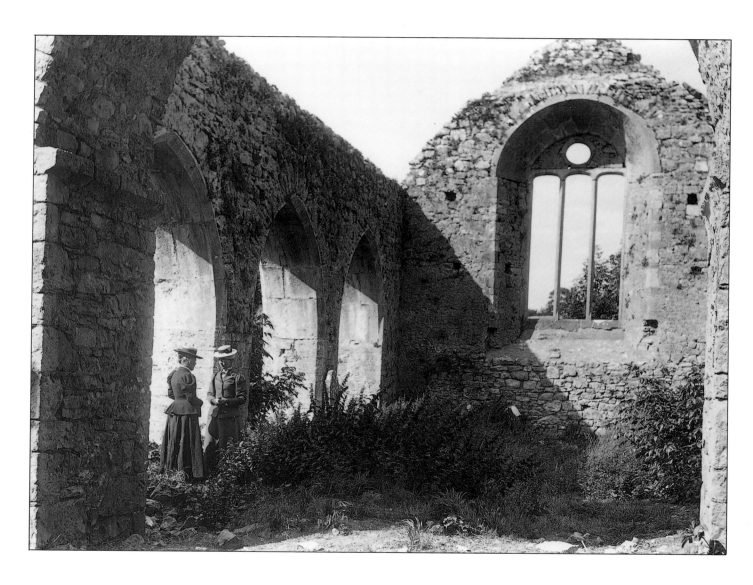

Two ladies dressed in the costume of the
day about 1897 at the 12th-century
Augustinian Priory at Kells, Co. Kilkenny.
Most of the existing buildings date from
the 15th century.

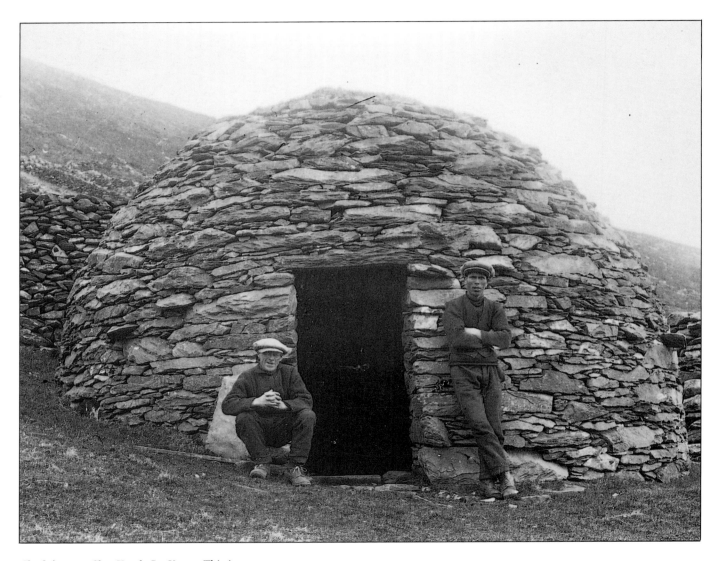

Clochán near Slea Head, Co. Kerry. This is
not an early structure but was built in the
ancient style about 1900 by local farmers,
probably to house animals.

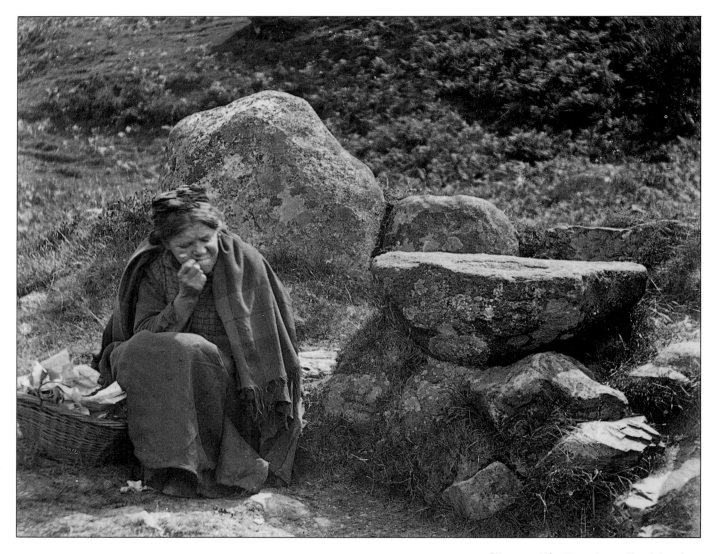

Woman at the **Deerstone,** Glendalough.
One of the many legends of Glendalough
concerns the deer who, at St Kevin's
request, shed her milk into this hollow
granite basin to feed the motherless twins
of one of Kevin's workers.

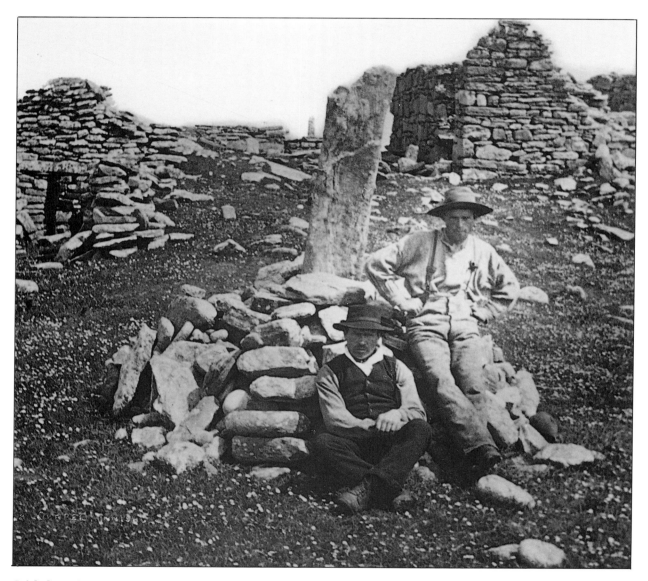

Inishglora, Co. Mayo, early monastery.
Two local fishermen pose at one of the
pilgrims' 'stations' associated with the
6th-century monastery founded by St
Brendan the Navigator.

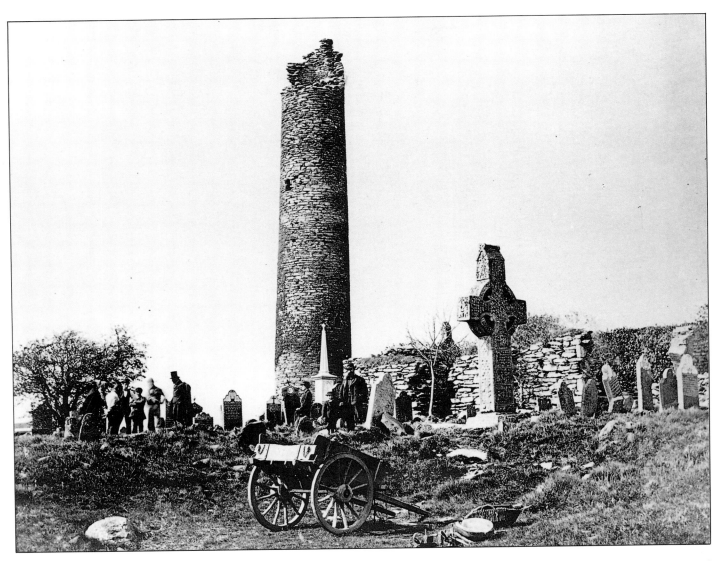

Monasterboice, Co. Louth, early monastery. A funeral service at the site of the monastery founded by St Buite in the 6th century. The cross of Muiredach here is probably the finest of all the Irish high crosses. The round tower, containing a library and other treasures, was burned in 1097. This photograph dates from the 1880s.

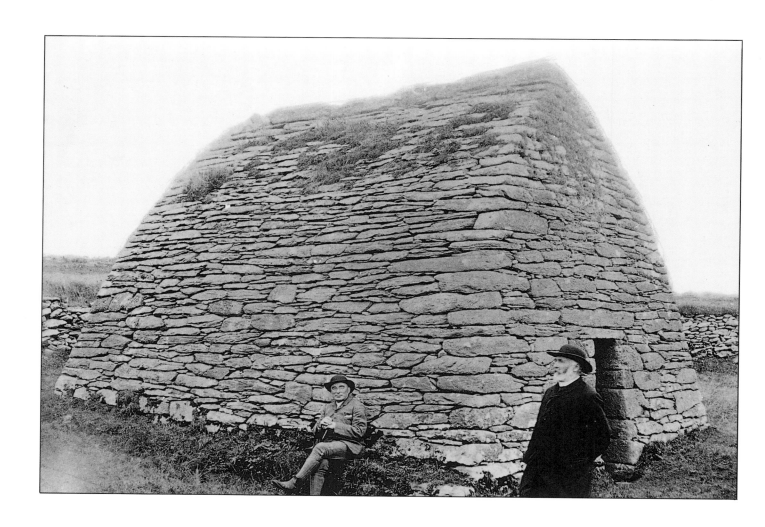

Dr George Stokes and the Rev. D. Murphy
at **Gallarus Oratory,** Dingle, Co. Kerry, in
1899. This dry-stone structure is the most
perfectly preserved of the boat-shaped
oratories.

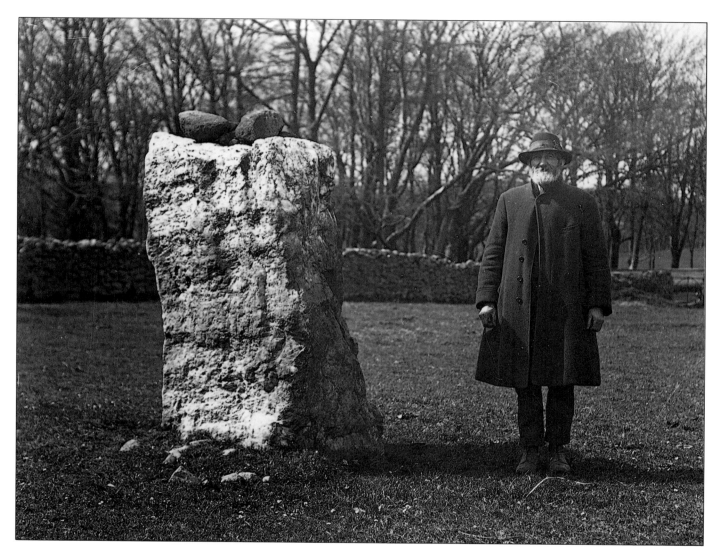

Glencullen, Co. Dublin, pillar stone. Standing beside a standing stone. Traditionally known as Clochnagon: 'the Stone of the Hounds'.

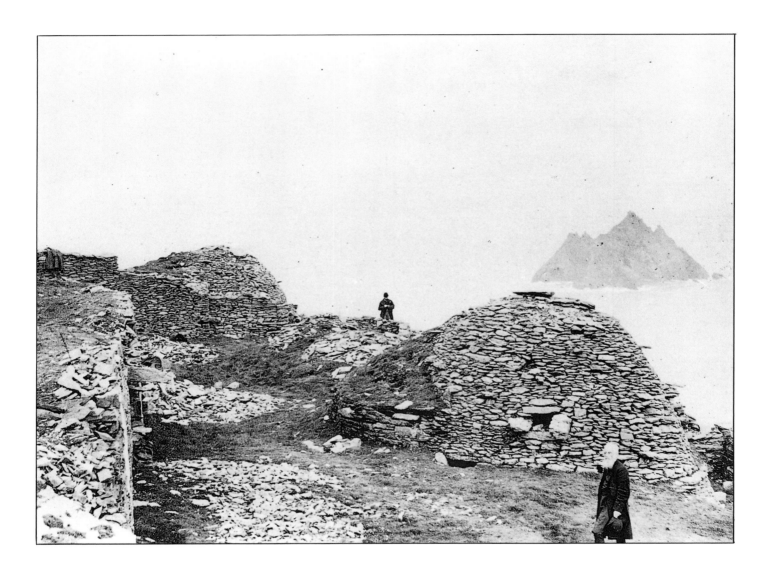

Skellig Michael, Co. Kerry, showing Little Skellig on the right-hand side of the picture. This island monastic site was founded in the 6th or 7th century. Lying eight miles from the mainland, its monastic enclosure contains two dry-stone oratories and six dry-stone cells. It was abandoned in the 12th century but continued as a place of pilgrimage throughout the medieval period.

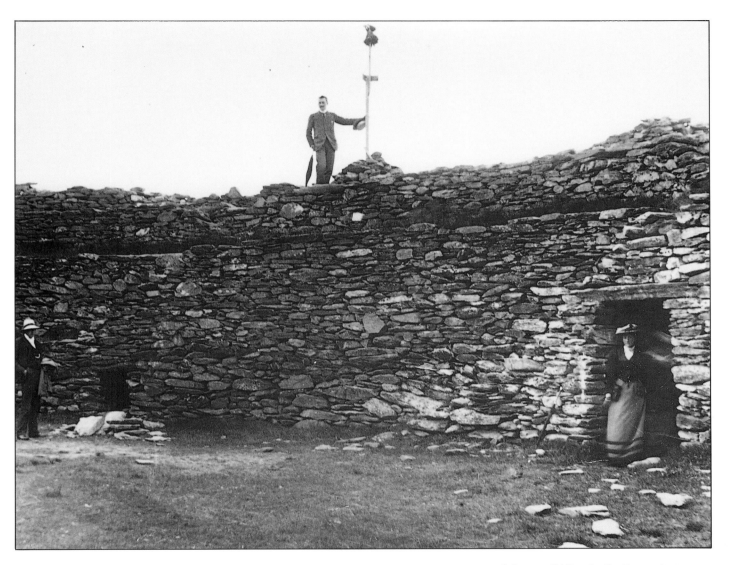

Grianan of Aileach, Co. Donegal, stone fort. Three strange visitors at the walls of the monument. Legend says that this tall circular stone structure was built by the ancient gods, but though its date is unknown, it was probably built sometime in the early centuries of the Christian era.

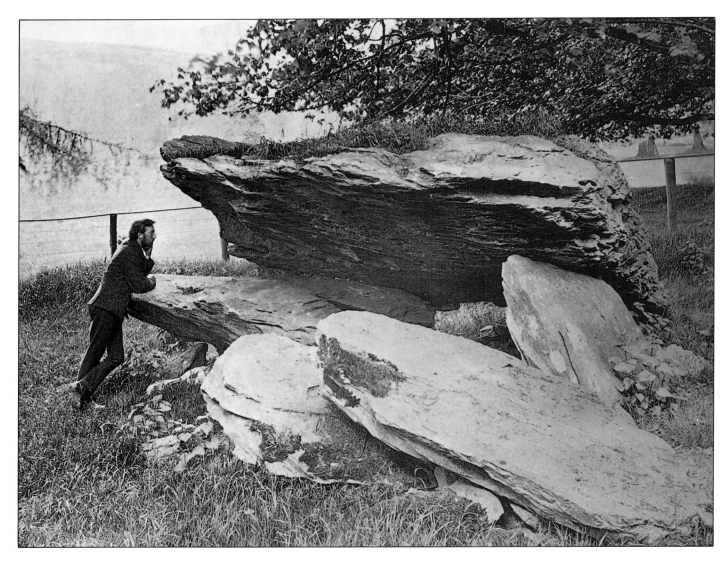

Castlemary, near Cloyne, Co. Cork,
*c.*1890–1900. Leaning on the megalithic
tomb.

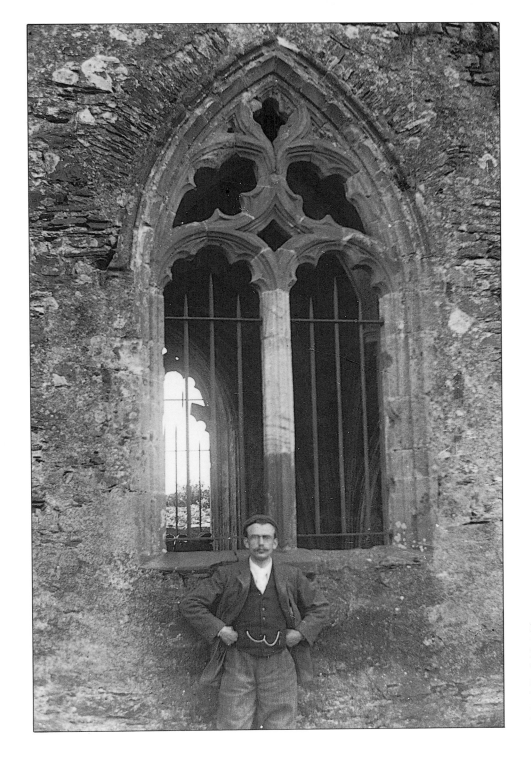

Mellifont Abbey, Co. Louth, 11 June 1897. St Malachy of Armagh brought a handful of monks with him from France to found the first Irish Cistercian monastery here in 1142. Of the structures only the lavabo and chapter house survive. We see here the elaborate south window of the chapter house.

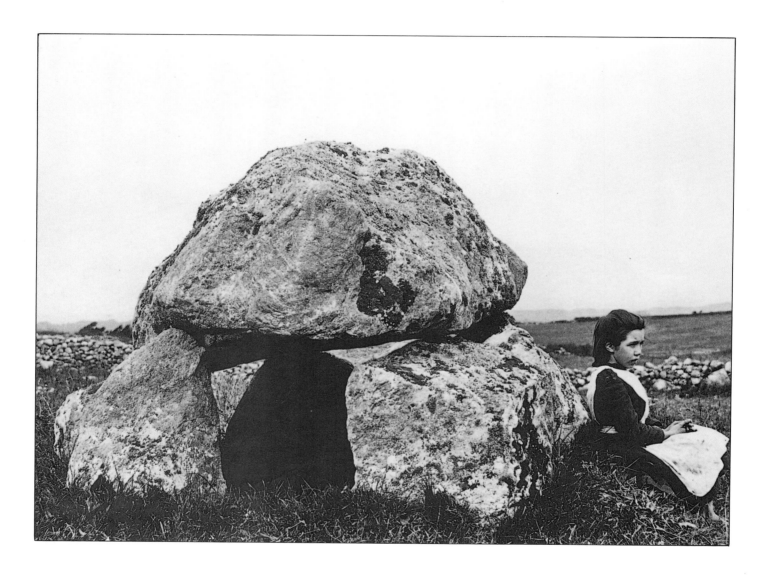

Carrowmore, Co. Sligo, megalithic cemetery *c.*1900. A youthful face beside ancient stones. One of the surviving tombs at Carrowmore, the largest Stone Age cemetery in Ireland.

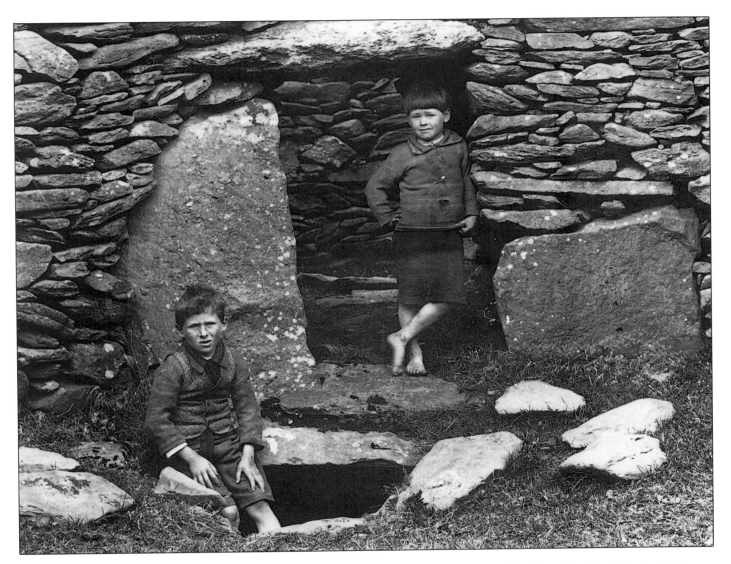

Glanfahan, Slea Head, Dingle, Co. Kerry.
The photograph of the two boys was taken
in one of the cathairs at the entrance to a
souterrain. These souterrains were used
both as a means of escape and for cold
storage.

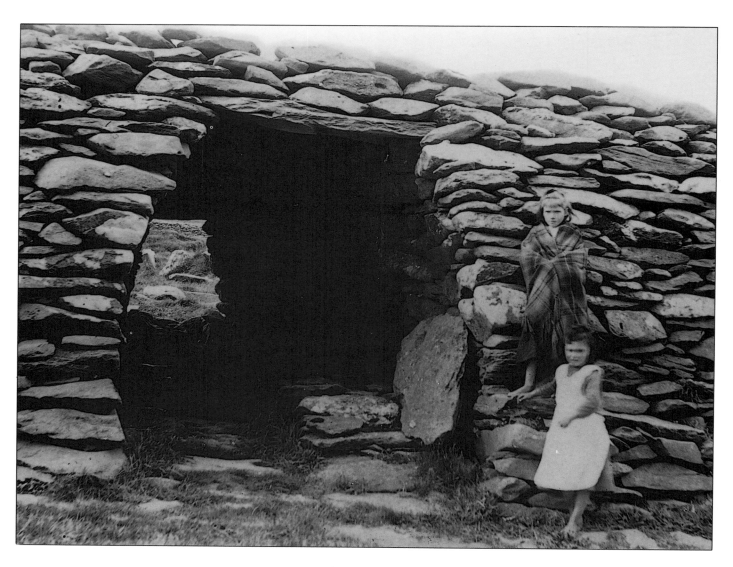

Two local girls at **Dunbeg Promontory Fort,** Co. Kerry. The fort has four outer defensive banks of stone and earth, and inside is a strong stone wall which had two phases of construction, the inner section being older. A souterrain runs from the lintelled entrance in the stone wall towards the front of the defences.

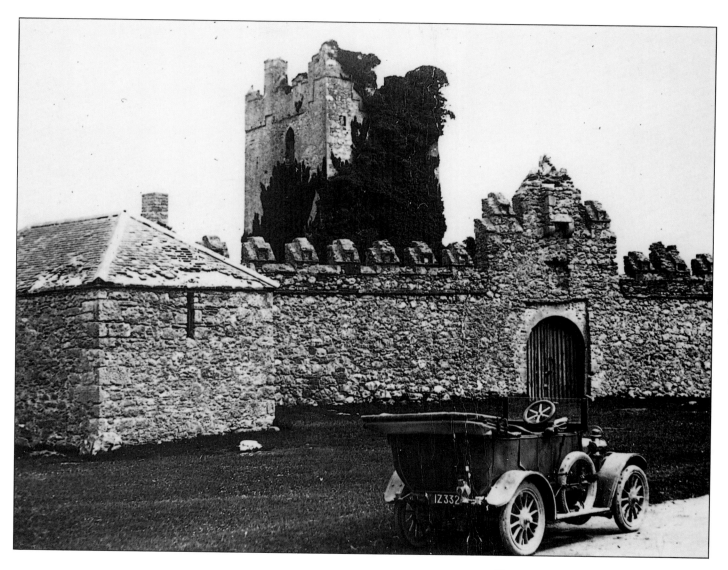

Clonony, Co. Offaly, showing the 16th-century castle. The arrival of motor transport in the early 20th century afforded easier access for some people to historic sites.

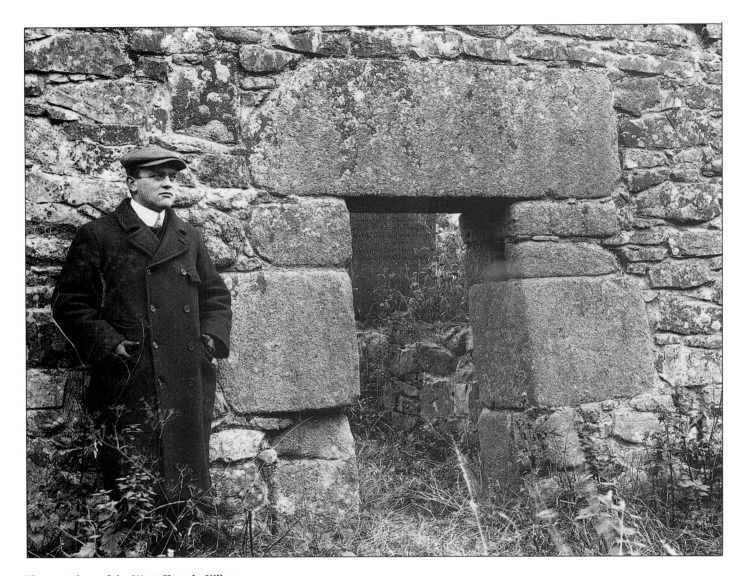

The west door of the **West Church, Killevy,**
Co. Armagh, 24 September 1908. Killevy
was one of Ireland's most important early
nunneries, founded in the 5th century. The
massive lintelled doorway being 'guarded'
in this photograph dates from the 10th or
11th century.

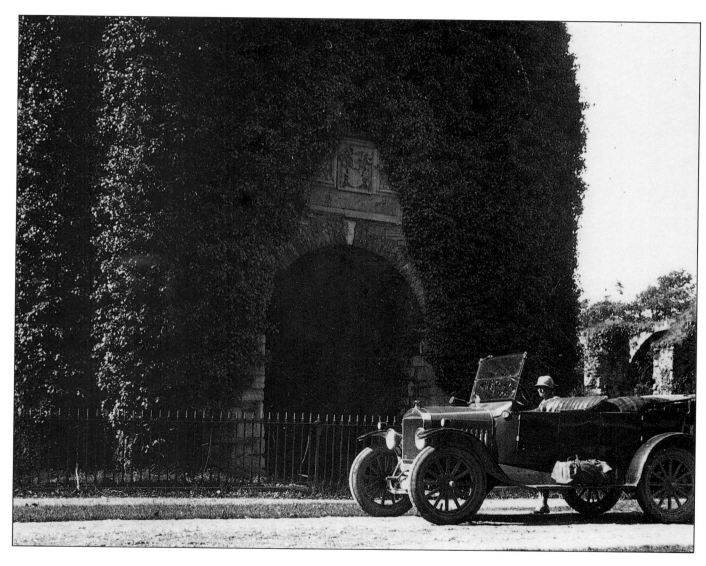

Maynooth, Co. Kildare. The ivy-shrouded gatehouse of Maynooth Castle, stronghold of the Fitzgeralds, the Earls of Kildare, until 1707. Their family crest appears above the archway.

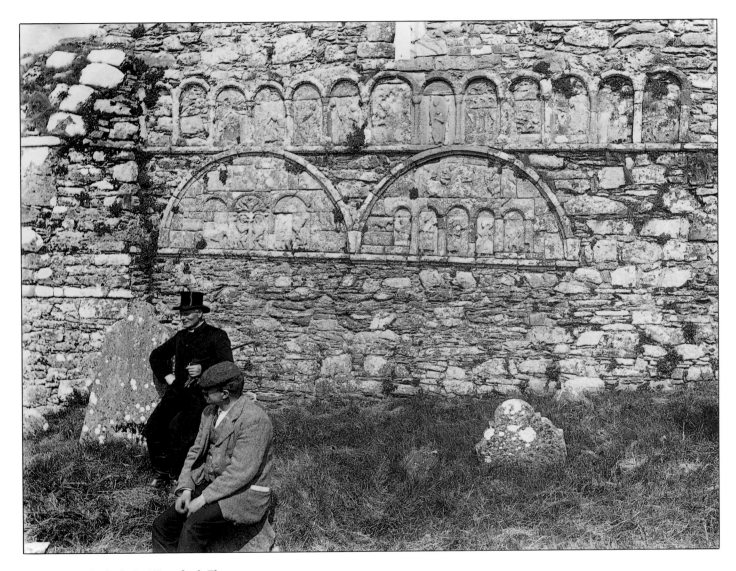

Ardmore Cathedral, Co. Waterford. The
west wall shown here has unusual
Romanesque sculptures within a series of
arcades. The church dates mainly from
the 12th century.

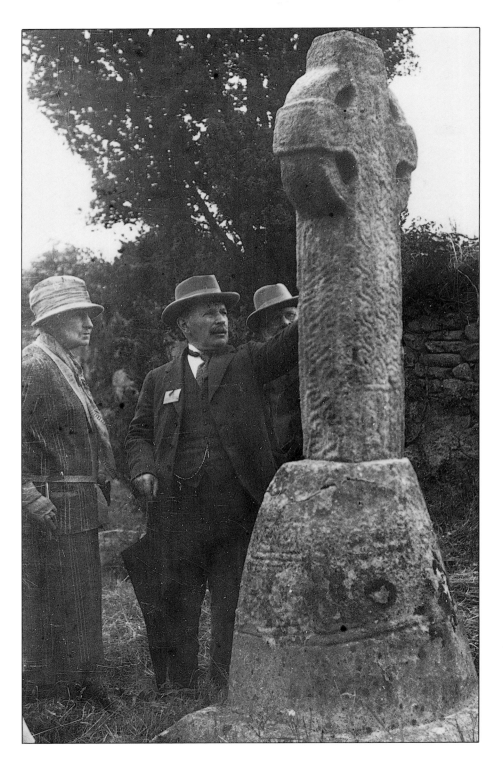

Graiguenamanagh, Co. Kilkenny. The graveyard at Graiguenamanagh Abbey contains two granite high crosses. The cross in this picture came from Ballyogan, and has representations of King David, the Sacrifice of Isaac, Adam and Eve, and the Crucifixion on the east face and spirals on the west.

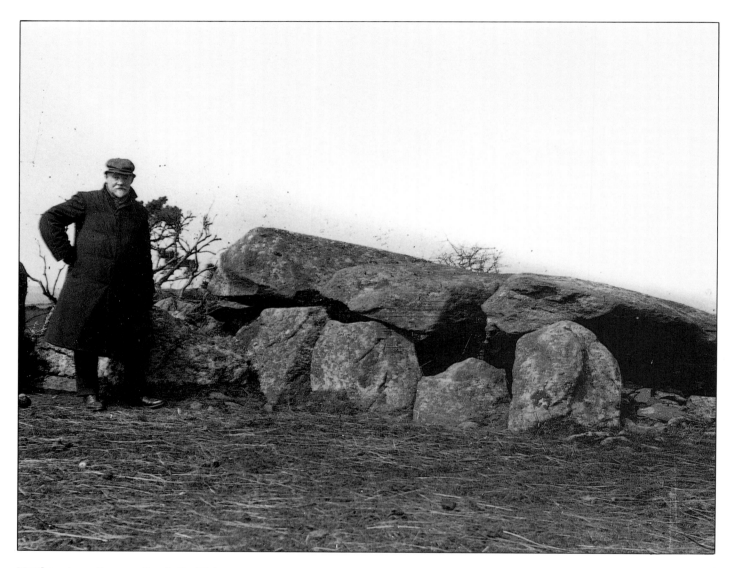

Matthewstown Passage Tomb, Co. Water-
ford, 1911. Some of the original kerb-
stones remain though the covering mound
is completely gone.

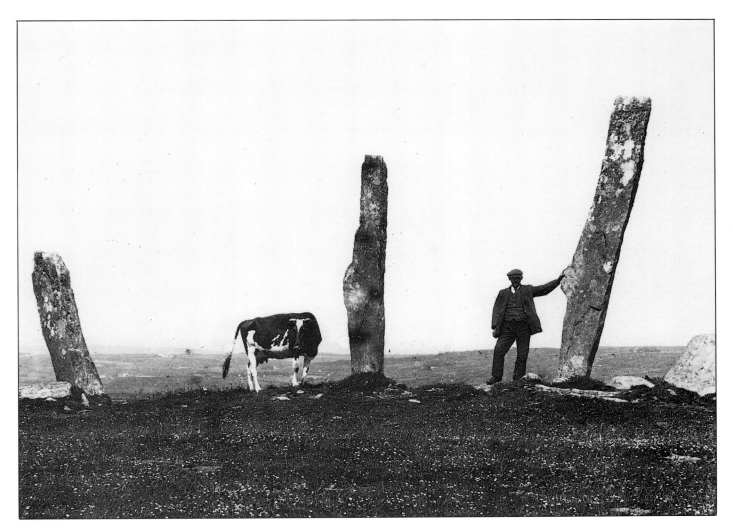

Gurranes, Co. Cork, stone alignment,
1913. This stone alignment in West Cork
is known locally as the 'Finger Stones'.

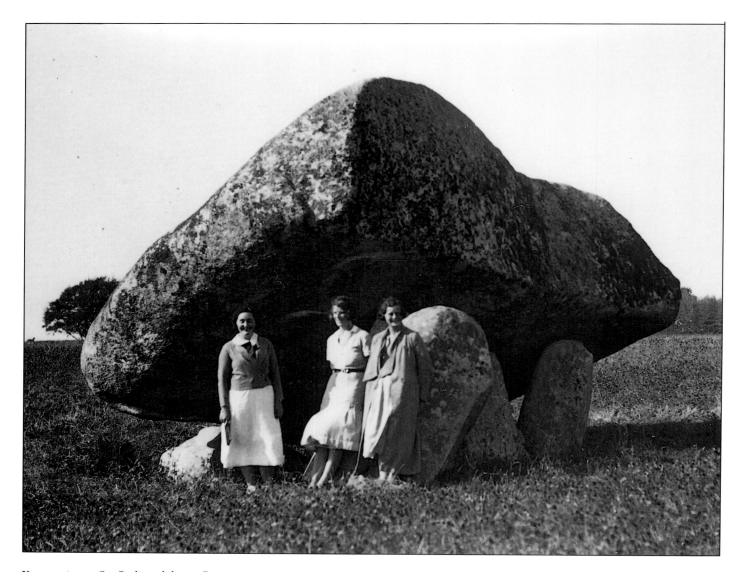

Kernanstown, Co. Carlow, dolmen. Better
known as Browneshill Dolmen, it is the
largest dolmen in Ireland. The capstone is
reputed to weigh over 100 tons.

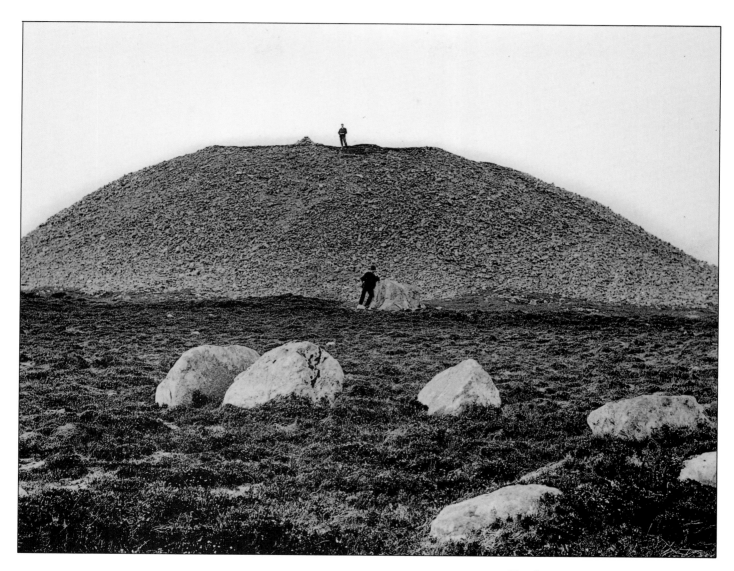

Knocknarea Cairn, Co. Sligo, 1894. This massive stone cairn, associated with the legendary Maeve, the fiery queen of Connacht, probably conceals a Stone Age passage tomb.

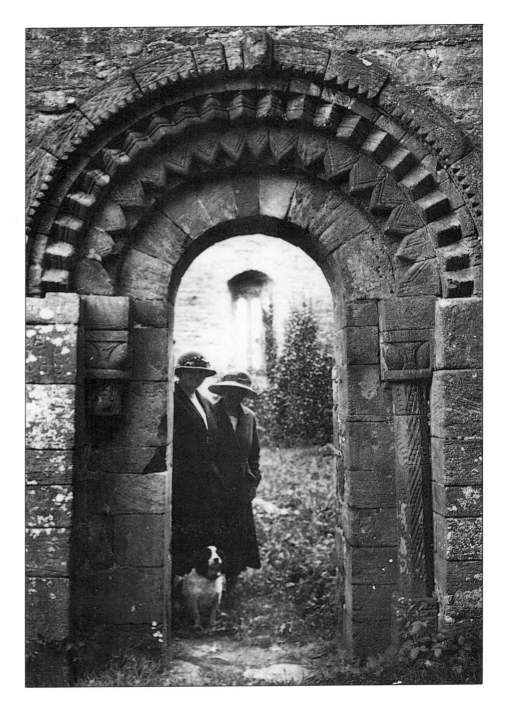

Peeping out through the Romanesque
doorway at **Clonkeen,** Co. Limerick, 1925.

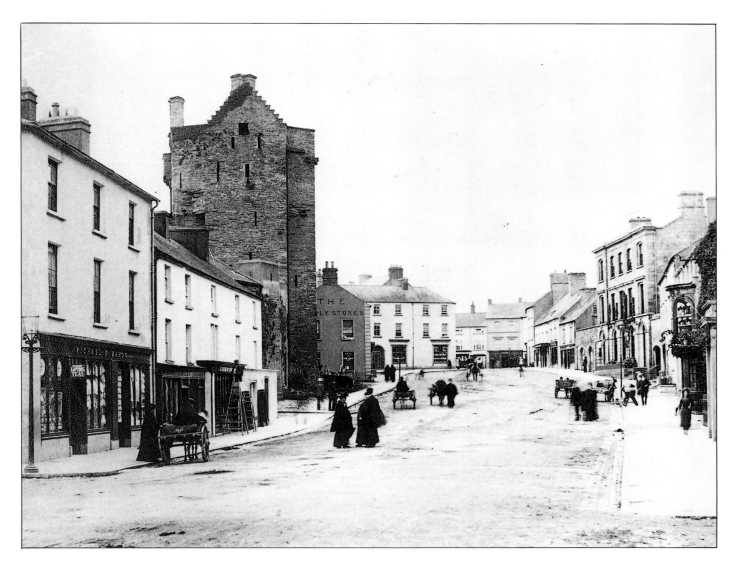

Roscrea, Co. Tipperary, showing the 13th-century castle. The rectangular gate tower had a portcullis and drawbridge. The upper storey was altered in the 16th or 17th century and the curtain wall, which encloses a courtyard (in which stands Damer House), has two D-shaped towers.

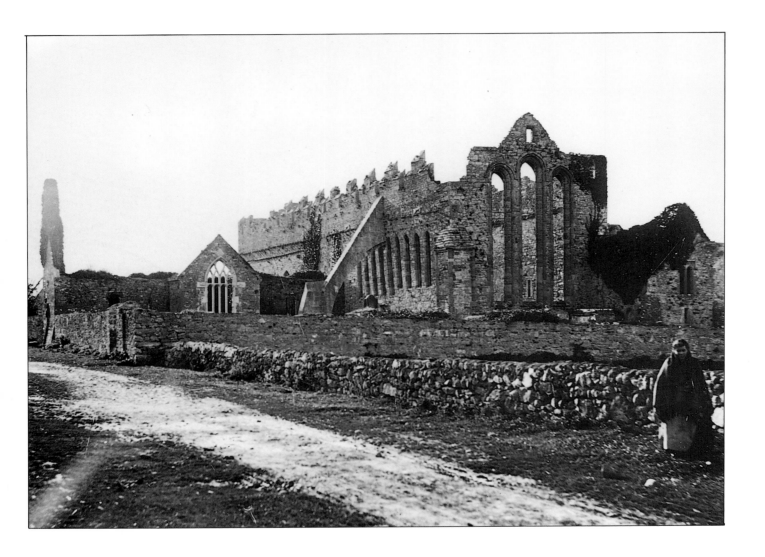

Ardfert Cathedral, Co. Kerry. This cathedral dates from the 13th century but incorporates part of the west end of a 12th-century Romanesque cathedral, comprising a doorway and blind arcading. The south transept is a later addition.

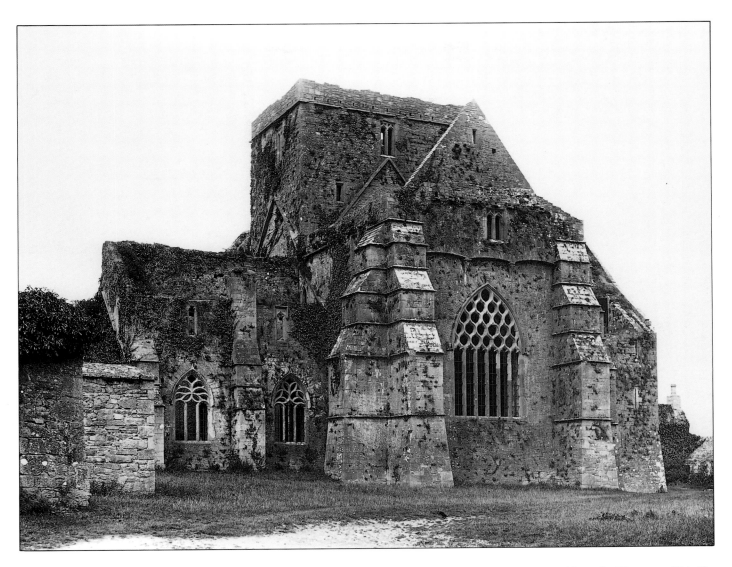

Holycross Abbey, Co. Tipperary. This Cistercian abbey has some of the finest stone building of the 15th century in Ireland. Remains include ribbed vaulting and fine traceried windows. The north transept has one of the few medieval wall paintings which survive.

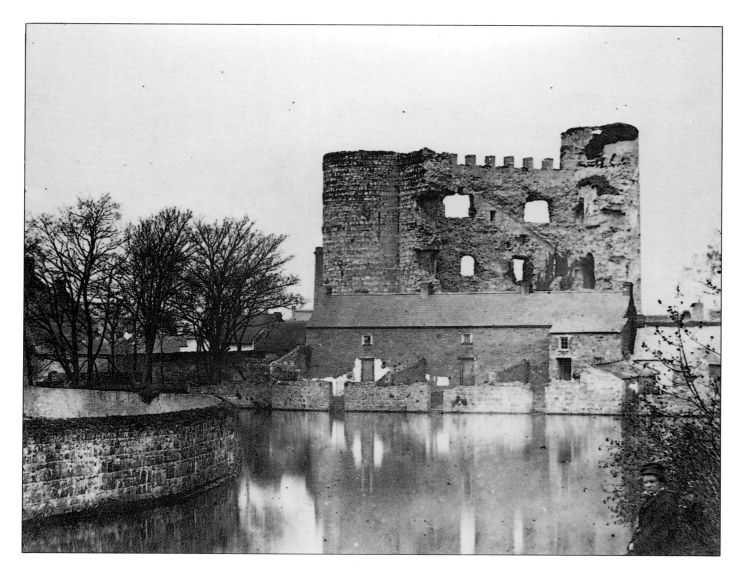

Carlow Castle. This must have been one of the finest Norman castles, but only two of the original four towers of this large keep remain. It was taken by Cromwell in 1650 but was later returned to its previous owner, the Duke of Thomond.

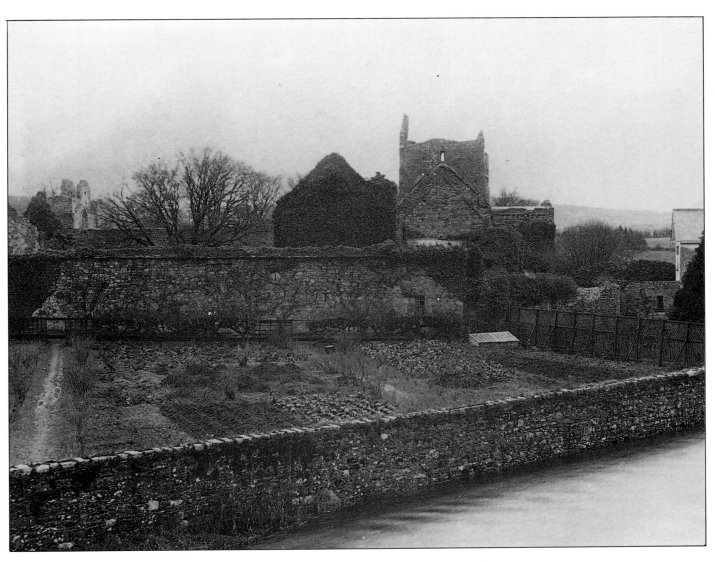

Boyle Abbey, Co. Roscommon,
18 December 1894. A cultivated garden
beside the remains of Boyle Abbey is a
reminderof the early monks' efforts to be
self-supporting farmers dedicated to a life
of prayer. Here, in 1161, beside the River

Boyle, the Cistercians founded one of the
most important abbeys in Connacht.

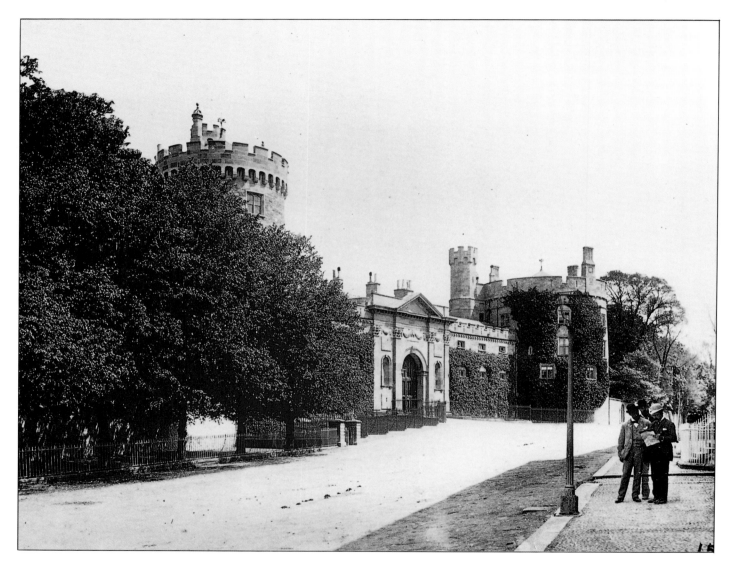

Kilkenny Castle, taken from the parade. The present exterior of the castle dates mainly to the 19th century. The castle still retains much of its early quadrangular form with rounded towers at the corners. It was first built by William Marshall in the early 13th century, and became one of the castles of the powerful Butlers of Ormond.

Drogheda, Co. Louth, St Mary D'Urso. During the Middle Ages, Drogheda was one of the most important English towns in Ireland. Here, in Old Abbey Lane, are the remains of the church of the Augustinian Crucifers Priory and hospital of St Mary d'Urso, founded in 1206.

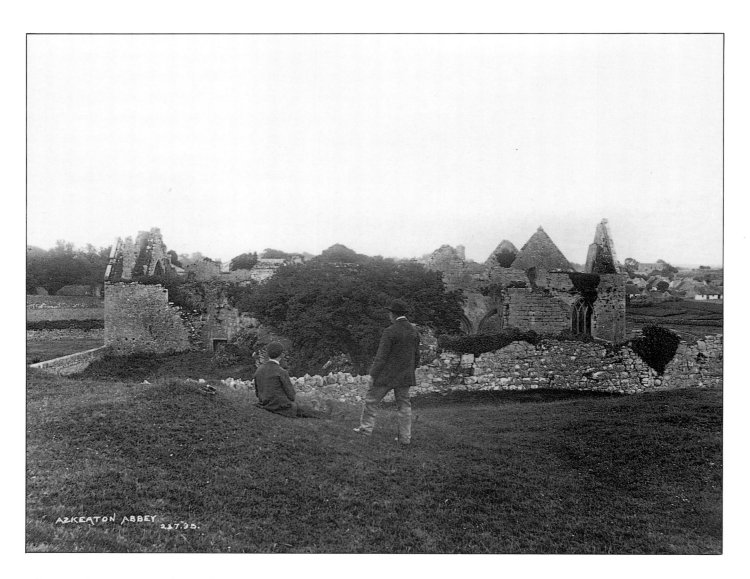

Askeaton Friary, Co. Limerick, 23 July 1895. One of the photographs taken by the firm of T.F. Geoghegan showing the late 14th-century Franciscan friary. It was plundered in 1579 but revived again in 1627 and continued to be used by the friars until as late as 1714.

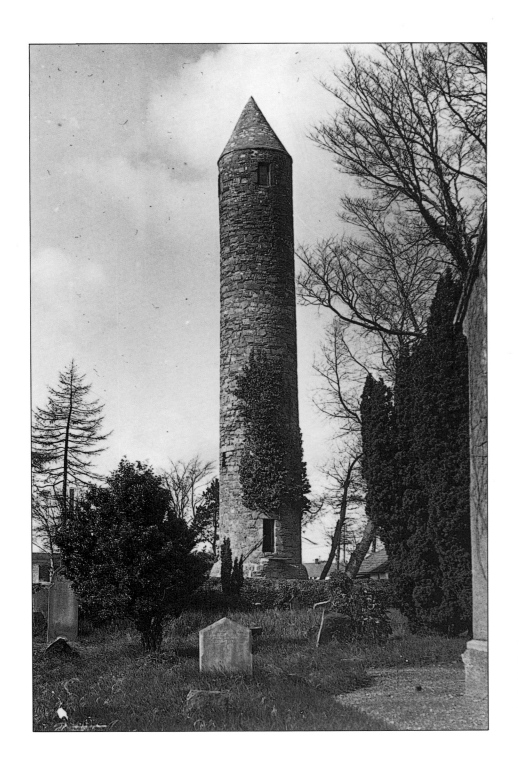

Clondalkin, Co. Dublin, round tower, about 1900. A monastery was founded here around the 7th century by St Cronan. It was plundered by the Vikings in 832. The fine round tower is the most striking of the remains.

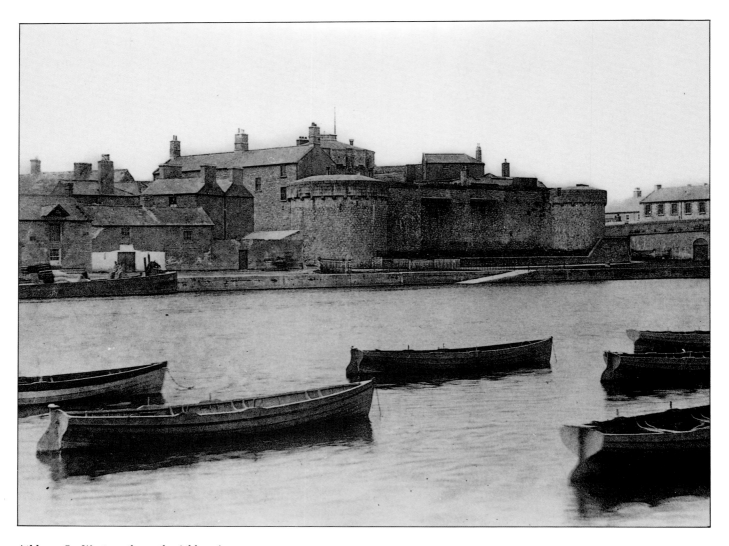

Athlone, Co. Westmeath, castle. Athlone is
an important communications centre at the
principal Leinster/Connacht crossing of the
Shannon. The original town grew up in the
shadow of this strong medieval castle which
commands the crossing from the west bank.

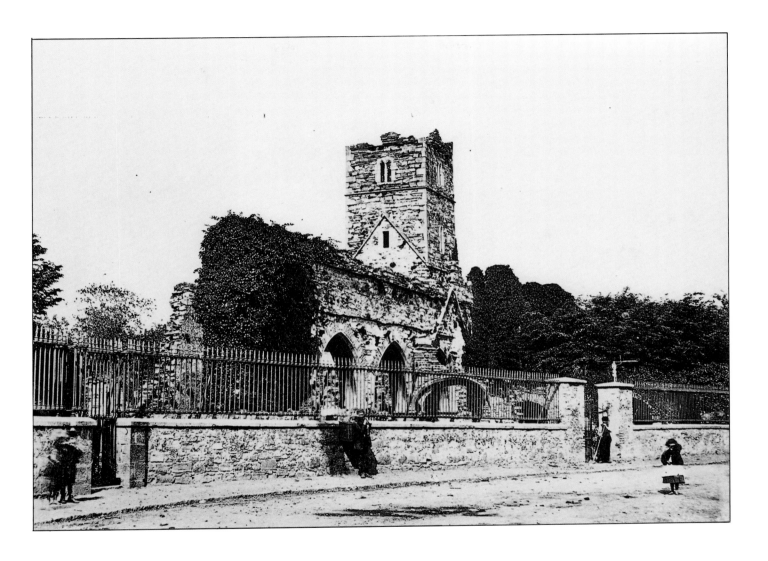

Sligo Town, friary. The sun shines brightly on the overgrown remains of the town's sole surviving medieval monument. Founded in the middle of the 13th century for the Dominicans by Maurice FitzGerald, who was also founder of the town.

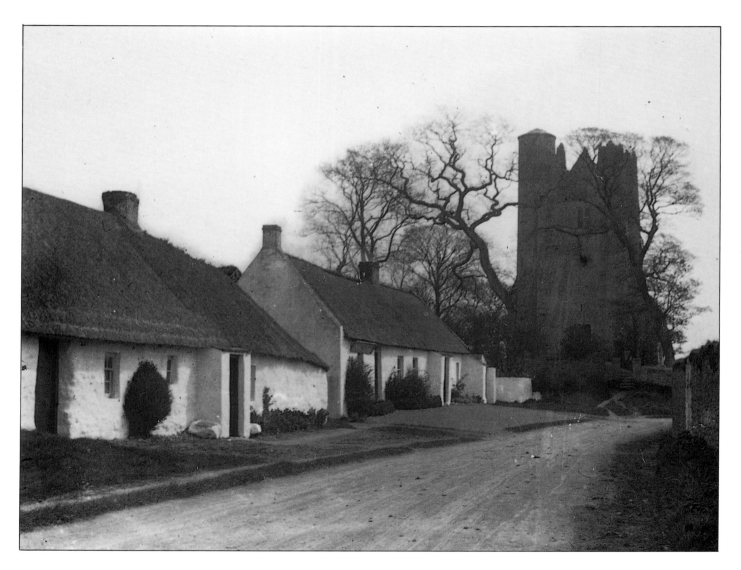

Lusk, Co. Dublin, church and round tower. The impressive remains of the medieval church of Lusk look down on a neat row of thatched houses. Of the Early Christian monastery, founded on the site by St Macculin about A.D. 500, only the round tower, incorporated into the medieval structure, remains.

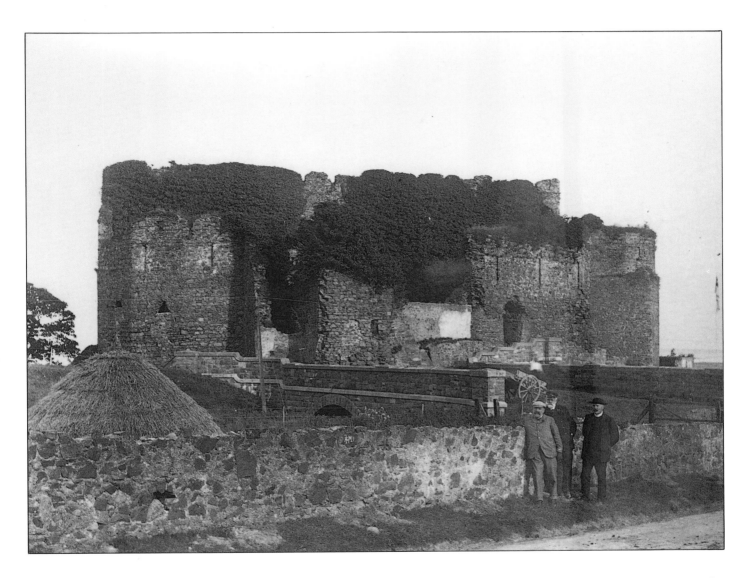

King John's Castle, Carlingford, Co. Louth, *c.*1902. The railway bridge leads to the shattered but impressive remains of Carlingford Castle. In the Middle Ages a settlement grew up here under the shadow of the castle, first built in the 12th century by Hugh de Lacy.

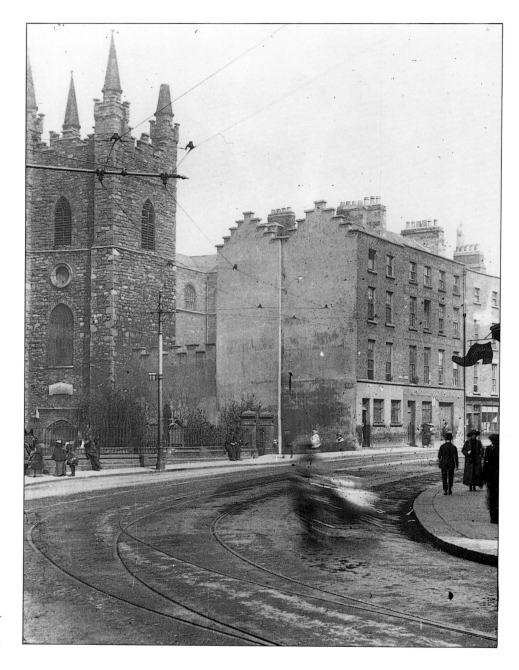

St Audoen's Church, High Street, Dublin City, 1913. The church was dedicated to the Norman saint, Audoen of Rouen, and was once the leading parish church in the city. The square tower contains the three oldest bells in Ireland, dated to 1423. Archaeological excavation has shown that since medieval times the ground has risen by over 4 metres.

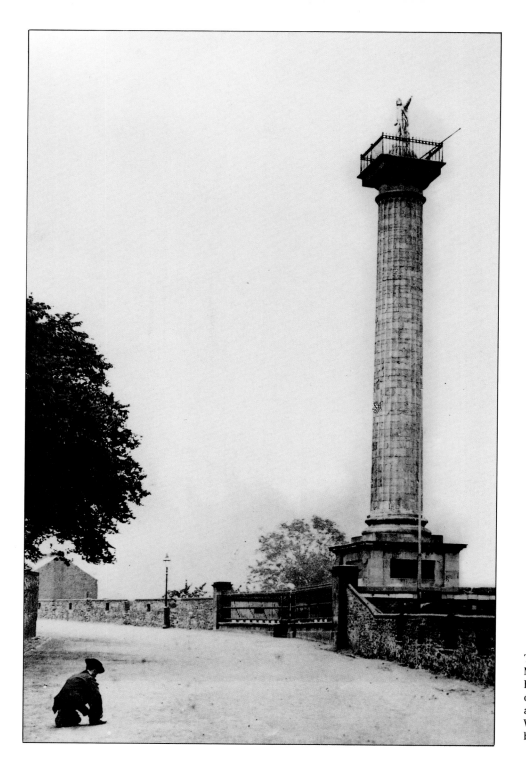

The Walls of Derry and the Walker Monument *c.*1870. These famous walls have withstood several sieges, the most celebrated lasting 105 days in 1688–9 against the forces of James II. The Walker Monument was destroyed by a bomb in 1973.

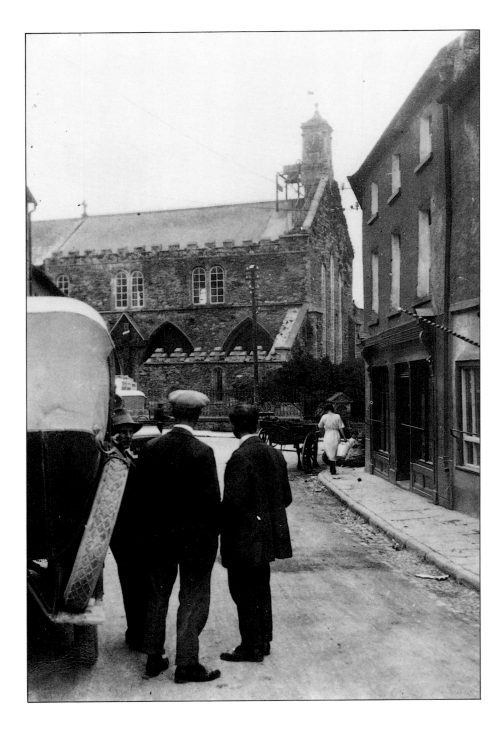

Graiguenamanagh, Co. Kilkenny, in 1926. The restored Cistercian abbey was founded by William Marshall in 1207. The cloister, chapter house and domestic buildings remain in part, but are hidden within modern buildings. The baptistry has a fine 13th-century doorway.

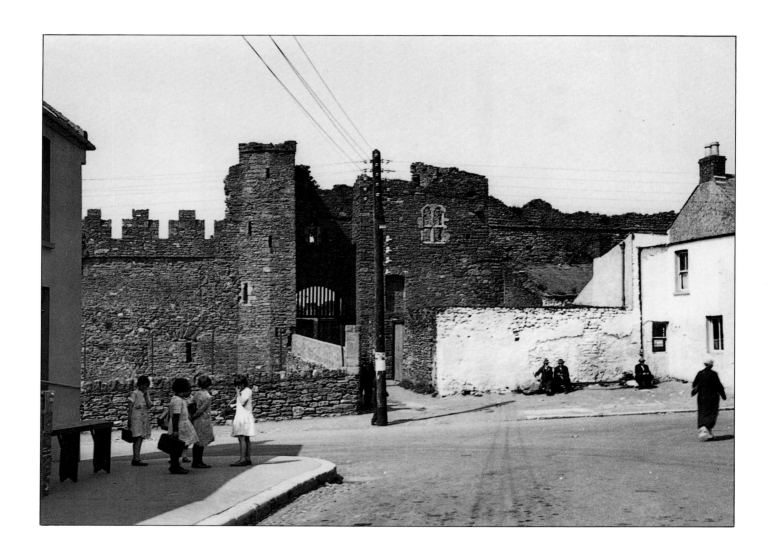

Swords, Co. Dublin. This photograph shows the village and castle on a hot summer's day in June 1934. The castle was originally built around 1200 as an episcopal manor for the archbishops of Dublin.

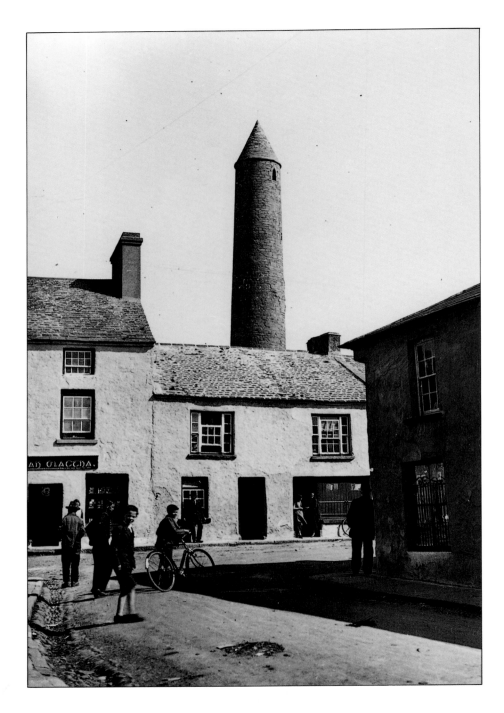

Killala, Co. Mayo, round tower. Killala, which is 6 miles north of Ballina, takes its name from a church founded here by St Patrick. This photograph, taken in 1936, shows the village with its fine 26-metre-high round tower.

INDEX

Graiguenamanagh, Abbey	Co. Kilkenny	76
Graiguenamanagh, Cross	Co. Kilkenny	55
Grangefertagh, Round Tower	Co. Kilkenny	26
Grianan of Aileach, Stone Fort	Co. Donegal	45
Gurranes, Standing Stones	Co. Cork	57
Holycross, Abbey	Co. Tipperary	63
Inch, Abbey	Co. Down	18
Inishglora, Monastery	Co. Mayo	40
Inishmore, Temple Benen	Co. Galway	30
Jerpoint, Abbey	Co. Kilkenny	10
Kells, Priory	Co. Kilkenny	37
Kells, St Columb's House	Co. Meath	6
Kernanstown, Dolmen	Co. Carlow	58
Kilkenny, Castle	Co. Kilkenny	66
Killala, Co. Mayo	Co. Mayo	78
Killevy, Church	Co. Armagh	52
Kilmacduagh, Round Tower	Co. Galway	21
Kilmalkedar, Church	Co. Kerry	34
Kilmalkedar, Romanesque Doorway	Co. Kerry	35
Kilmogue, Dolmen	Co. Kilkenny	20
Knocknarea, Cairn	Co. Sligo	59
Labbacallee, Wedge Tomb	Co. Cork	29
Lislaughtin, Friary	Co. Kerry	11
Lusk, Church and Round Tower	Co. Dublin	72
Matthewstown, Passage Tomb	Co. Waterford	56
Maynooth, Castle	Co. Kildare	53
Mellifont, Abbey	Co. Louth	47
Monasterboice, Monastery	Co. Louth	41
Muckross, Friary	Co. Kerry	14
Newgrange, Passage Tomb	Co. Meath	1
Newgrange, Entrance Stone	Co. Meath	31
Quin, Friary	Co. Clare	5